BAKEWELL & THE WYE VALLEY

THROUGH TIME

Alan Roberts

AMBERLEY PUBLISHING

First published 2013

Amberley Publishing
The Hill, Stroud, Gloucestershire, GL5 4EP
www.amberley-books.com

Copyright © Alan Roberts, 2013

The right of Alan Roberts to be identified as the
Author of this work has been asserted in accordance with
the Copyrights, Designs and Patents Act 1988.

ISBN 978 1 4456 1406 9 (print)
ISBN 978 1 4456 1420 5 (ebook)

British Library Cataloguing in Publication Data.
A catalogue record for this book is available from the
British Library.

Typesetting by Amberley Publishing.
Printed in Great Britain.

Introduction

The Derbyshire Wye is only some 20 miles in length from its source in the high ground west of Buxton to its junction with the River Derwent at Rowsley, but in this short journey it passes a fascinating variety of scenery, with spectacular views, five nature reserves and the historic Haddon Hall set high above the river. An earlier book in this series, *Buxton Through Time*, covered the first 3 miles of the Wye's journey; this book picks up the story as the Wye leaves Buxton and passes through the narrow limestone dales from Ashwood Dale to Monsal Dale, then along a wider valley through Ashford and Bakewell to Rowsley.

For many centuries, this was a remote rural area with a few medieval watermills by the river but little else in the dales section. Bakewell was the main settlement along the valley and it had occupied a key role in the district since Saxon times. All Saints church in Bakewell is on the site of a Saxon church that was rebuilt in Norman times and on various occasions since. The early town was clustered round this church, high above the river, but gradually spread outwards towards the river as the town developed.

From the second half of the eighteenth century onwards, major changes began to occur along the Wye Valley, as the area's isolation decreased through the development of the turnpike road network that provided links to the wider region.

Ashford marble became popular as a decorative material, and in around 1750 the first of three mills to cut and polish this stone was set up in Ashford. Three cotton mills (one of them in Bakewell) were built around 1780. They employed around 1,000 people at their peak. All of these are now closed. Two of the buildings were converted into apartments in the 1990s.

The centre of Bakewell was redeveloped by the Duke of Rutland in the early 1800s, creating Rutland Square, the Rutland Arms Hotel and

the Granby Road market area for livestock auctions. A new road was built between Ashford and Buxton in 1810, which cut through the difficult terrain of Ashwood Dale, previously inaccessible to vehicles. The origins of the annual Bakewell Agricultural Show can be traced back to this period.

The railway from Derby to Rowsley was extended along the Wye Valley via Bakewell to Buxton in 1863, with difficult engineering works requiring several bridges and tunnels along the narrow dales between Monsal Dale and Buxton. The coming of the railway brought larger numbers of visitors to the area and also led to the opening of several limestone quarries close to the railway. The two large quarries in Millers Dale are now disused and one of these has become a nature reserve.

The Peak District National Park was established in 1948, the first national park in Britain. Most of the area covered by this book is within the national park and the head offices of the Park Authority are at Aldern House in Bakewell. In 1968, the railway line along the Wye Valley was closed to passenger traffic. Shortly afterwards, an 8-mile stretch of the track was purchased by the national park and opened as the Monsal Trail, but for safety reasons the longer tunnels were kept closed.

A further reshaping of Bakewell began in 1996, when the livestock market was moved to the newly built Agricultural Business Centre on the edge of the town, freeing up an underused area for new shops and housing close to the town centre.

The most recent change came in 2011. Following a major investment by the national park, the tunnels along the Monsal Trail were opened to the public, providing an uninterrupted route along the valley. Today, Bakewell remains an important centre for the surrounding rural community with its weekly stalls and livestock market, monthly farmers' market and annual show. Its interesting mixture of stone buildings, built from the sixteenth century (one of which houses the Old House Museum) to the present day, its variety of local shops in the small lanes and courtyards in the town centre, and its attractive riverside position maintain its popularity with visitors.

The other sections of the Wye Valley offer a wide range of outdoor experiences for walkers, cyclists, horse riders, climbers, nature lovers and those who just wish to admire the variety of spectacular views. This book sets out to describe some of the many factors that have helped to shape this interesting and varied area over the passage of time.

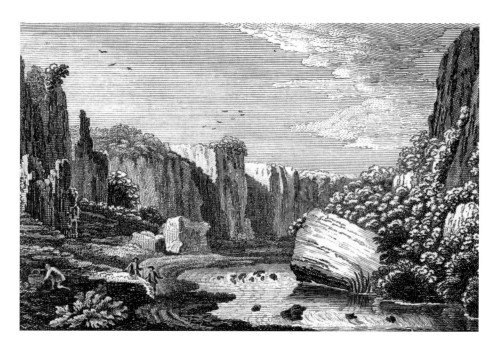

Early Days in Ashwood Dale

Ashwood Dale is the first of the limestone dales that the Wye encounters on leaving Buxton, a place of steep limestone cliffs in a narrow valley. The upper picture (1750s) gives a good impression of that time, when there was no road along the valley. The lower picture (originally 1850s) gives a view of the dale after the turnpike road was constructed in 1810, through difficult terrain. It was funded by the Duke of Devonshire as part of a landscaped route between Chatsworth and Buxton.

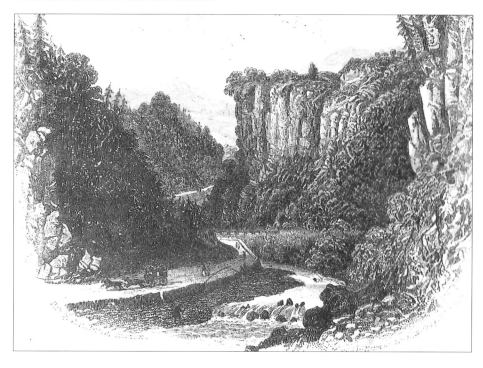

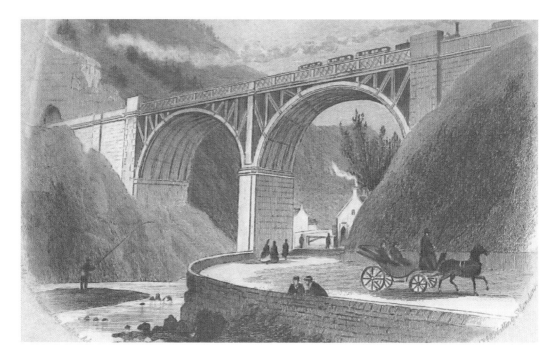

The Journey along Ashwood Dale

The upper picture shows a train emerging from Pictor tunnel, high above the river, and also the toll-house and gate near to the bridge, with the river, road and railway confined to a narrow gap. The railway opened in 1863 and the toll-gate was removed in 1878. The lower picture on the previous page shows the addition of a train to an earlier picture, near the river level and in totally the wrong place!

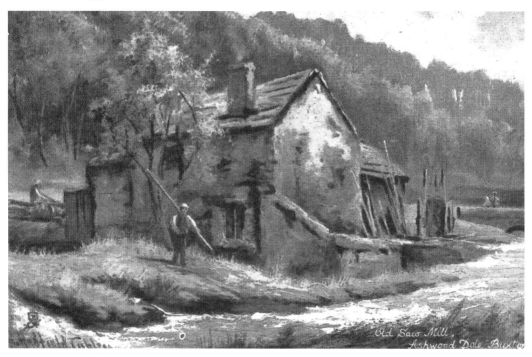

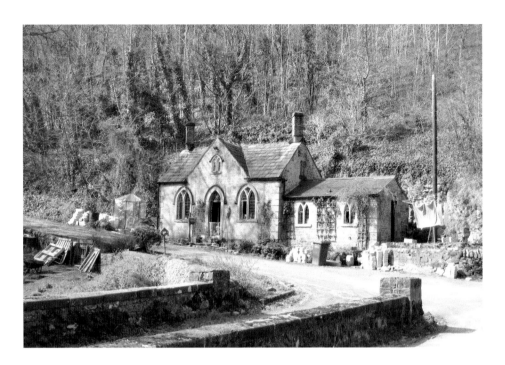

Entering the National Park

There were few buildings along this 3-mile stretch of the valley – the Devonshire Arms inn (now closed but undergoing rebuilding) and an eighteenth-century corn mill, later a sawmill, which is shown in the lower image on page 6. The site is now occupied by a small industrial building and the lodge to Pictor Hall, seen in the upper image. The hall itself is located on the high ground above the valley. Near the old mill site, the Wye Valley enters the Peak District National Park, as seen in the lower image (*see also page 71*).

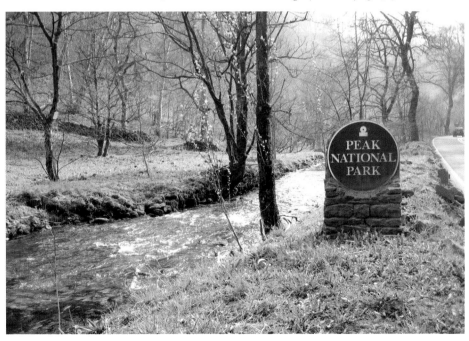

The Path to Blackwell Mill

Further on, the road climbs Topley Pike to cut off a large loop in the river on the way to Ashford, and a small peaceful track continues by the side of the river to the site of Blackwell Mill, located where two side dales gave access to the valley. The setting of Blackwell Mill gave a scene much loved by nineteenth-century artists, as in the lower picture, with Castle Rocks in the background.

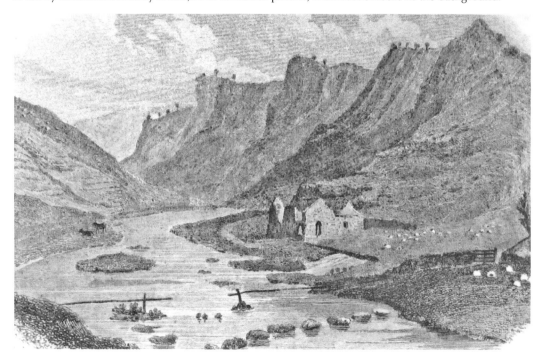

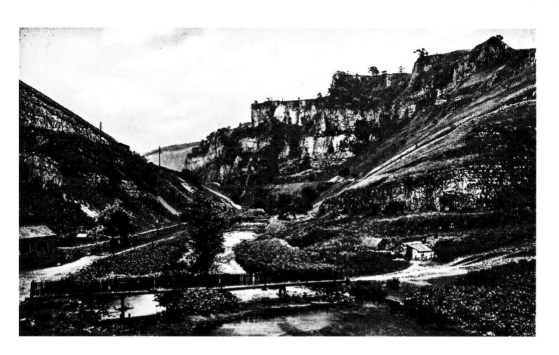

Castle Rocks

The railway along the Wye Valley to Buxton was opened in 1863, and the mill building was demolished at that time. The line to Buxton ran along the rocks on the right-hand side of the upper image, and a slightly later line to Manchester ran along the rocks on the left-hand side. These lines closed in 1968. Beyond the bridge, there is only a footpath at river level, passing Castle Rocks on the way to Chee Dale, seen in the lower image.

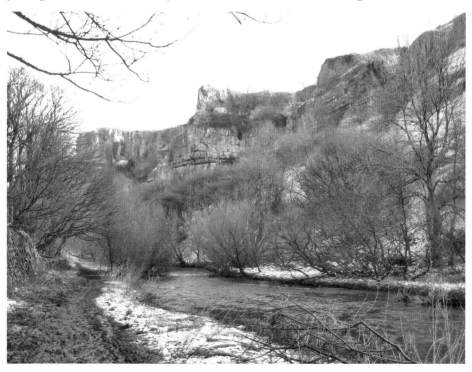

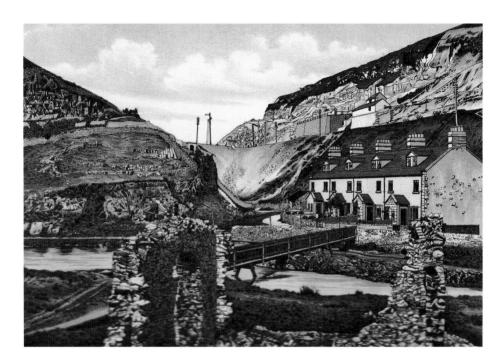

Blackwell Mill Cottages

In the upper image, the line to Manchester is high up on the right and the line on the left is a loop, still in use for freight traffic, which connects with the line to Buxton. Blackwell Mill Cottages were built for railway workers, including the signalmen who worked in the boxes controlling the three-way flow of traffic in this area. They were sold to private owners after the passenger lines closed in 1968.

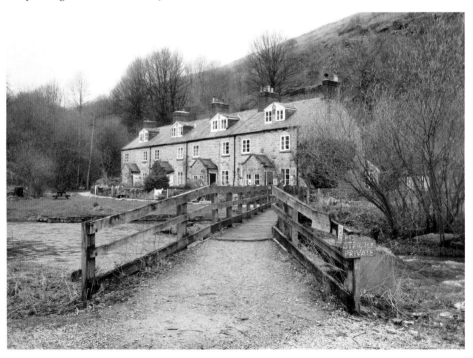

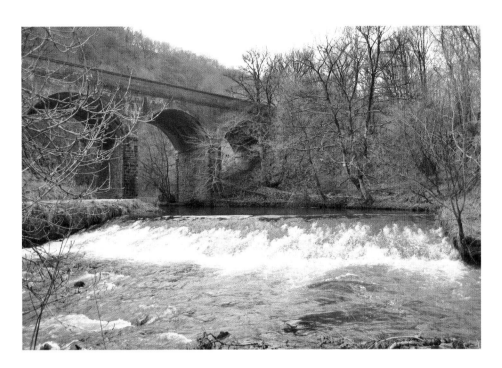

The Start of the Monsal Trail

In the upper image, the weir indicates the start of the former millstream for Blackwell Mill, while the bridge was part of the railway line to Buxton. This bridge now marks the start of the Monsal Trail (*see pages 28–33*) while in the lower image, the building houses a cycle hire business, which opened in 2011 when the tunnels on the trail were reopened.

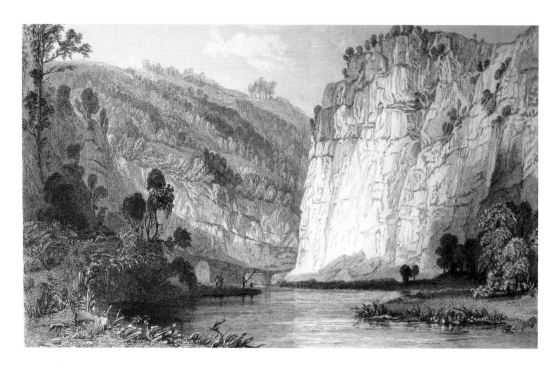

Chee Dale

After passing Castle Rocks, the Wye enters Chee Dale, the most spectacular part of its journey with its narrow valley and tall cliffs. Again, this is an area much loved by artists: The upper image (nineteenth century) shows the impressive Chee Tor, and the lower picture (1750s) shows Chee Dale on its approach to Millers Dale. The small weirs in this picture were made to improve conditions for fishing.

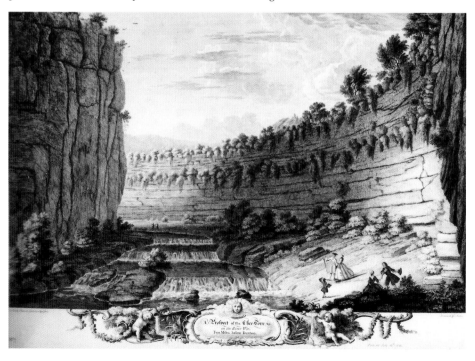

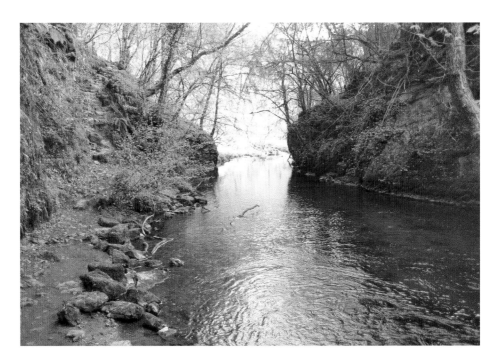

Spring in Chee Dale

In this narrow part of Chee Dale, the footpath has to make its way up the riverbank to carry on. These limestone dales are home to nationally important varieties of plants and wildlife. From Topley Pike through Chee Dale and on to Millers Dale there are five Derbyshire Wildlife Trust nature reserves, each one listed as a Site of Special Scientific Interest (SSSI).

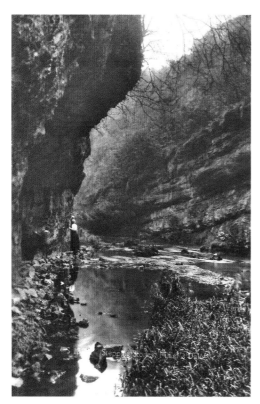

The Stepping Stones

In this section of Chee Dale, the overhanging rocks made it necessary to provide lengths of stepping stones to continue the path. At times of high water flow in the river, these stones are covered and the path is blocked. The images show the overhanging shape of the rocks, scoured away by the river in past millennia.

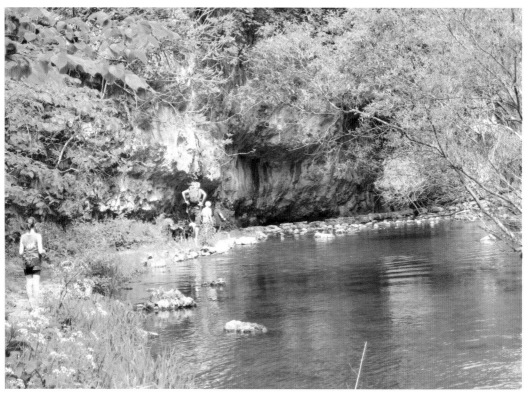

Rock Climbing

Many of the steep rock faces along these dales are recognised as climbing pitches, with names such as 'The Chicken Run', 'Goldfinger', 'The Flight of Icarus' and 'Aberration'. Near Millers Dale station, one can drop down to river level from a bridge licensed for abseiling.

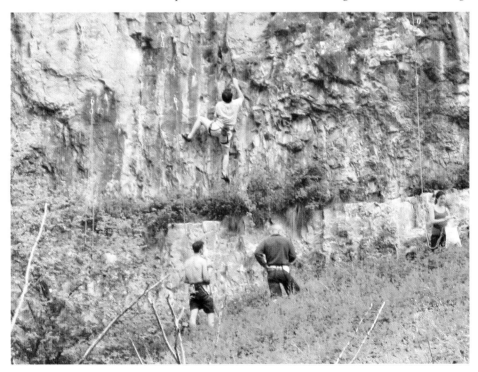

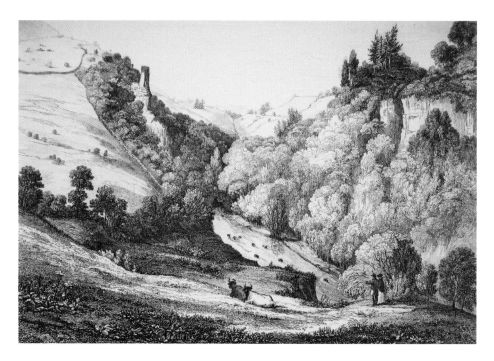

The Approach to Millers Dale

In the upper image, taken from the road leading down to the bridge in Millers Dale, the prominent stone on the left-hand side of Millers Dale is called the Peter Stone. The railway came along on the opposite side of the valley, and a large quarry (now disused) developed there because of the direct access to the railway. The lower image shows the imposing former limekiln by the side of the track.

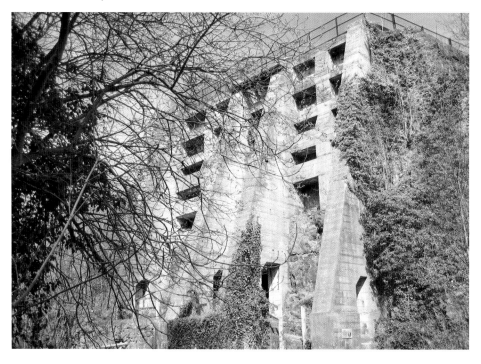

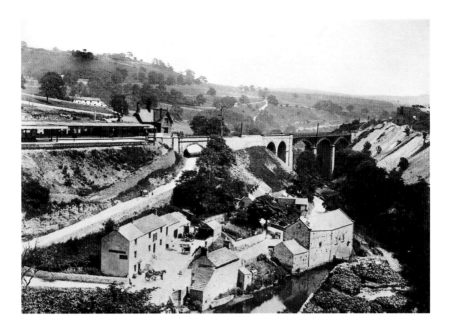

The First Mill and the Bridges

The upper image shows one of the Millers Dale corn mills at the front, with the V-shaped millpond by the side of the river. Millers Dale station and the first railway bridge over the river are in the middle of the image, with quarry buildings on the right (*also see page 29*). The lower image shows the road bridge and the buildings near the mill from a lower viewpoint. The long-disused Millers Dale Quarry is now an SSSI (*see page 13*).

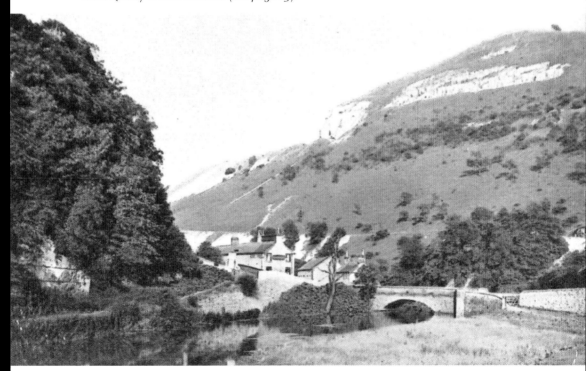

Millers Dale

The road through Millers Dale runs by the side of the river, past the church, and then climbs the hill to Tideswell, as seen in the upper image. Nearby, the Anglers Rest pub stands close to the river where a minor road branches off along the valley to Litton Mill.

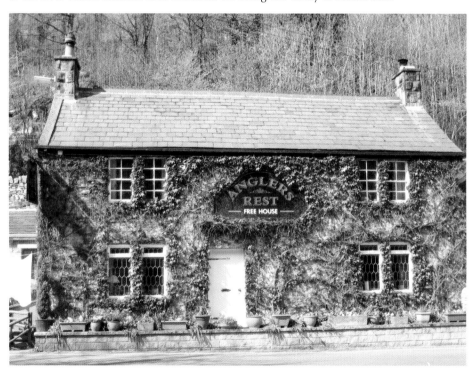

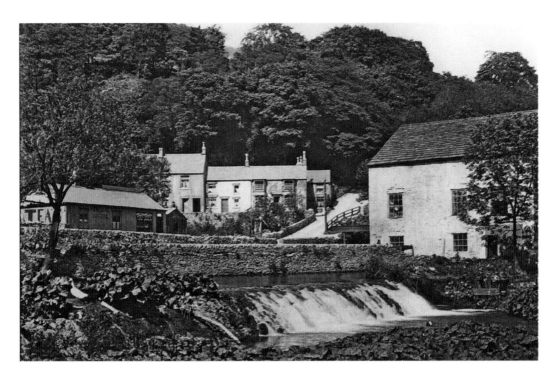

The Second Mill

The second corn mill, pictured above, stood close to the Anglers Rest and continued in operation until the 1970s; it was later demolished to make way for a small pumping station. After the mill was demolished, the mill wheel was restored by the Arkwright Society and it was mounted at the mill site, accompanied by a useful information panel.

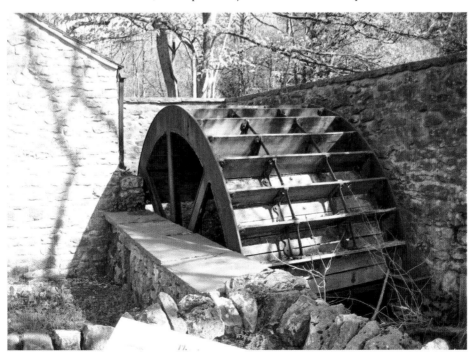

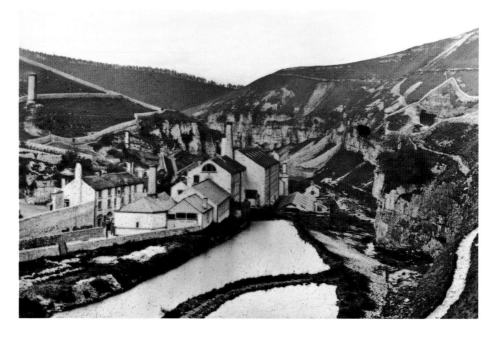

Litton Mill

The cotton mill at Litton was built in 1782 on the site of a former corn mill. It was one of three cotton mills built along the Wye. The upper image, from around 1900, shows the mill buildings and millpond; the mouth of Litton railway tunnel can be seen on the right-hand side of this picture. After various rebuildings, the mill buildings continued in use in the textile industry until the mid-1960s. The lower image shows the site today with its mixture of buildings of different ages.

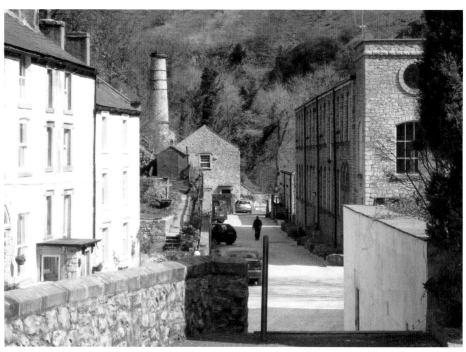

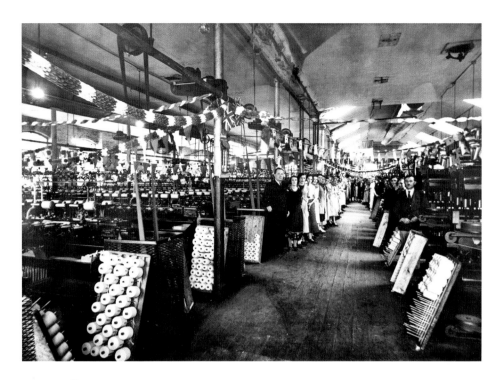

Litton Mill

The upper picture shows the interior of the mill in 1935, decorated for the Silver Jubilee of King George V. Following closure, the buildings stood empty for several years, but they were then converted to modern apartments in an attractive riverside setting, seen below. Beyond Litton Mill, a riverside path leads on to Cressbrook Mill through a narrow dale.

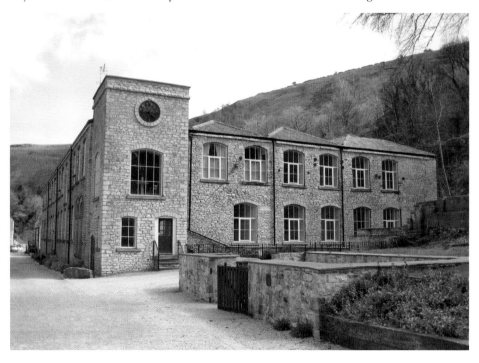

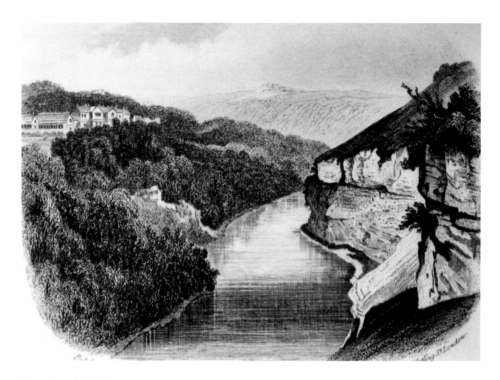

Cressbrook Mill

Cressbrook Mill was a cotton mill built by Sir Richard Arkwright in 1779. A later owner built Cressbrook Hall and housing for the workers at the mill in what became Cressbrook village, on the hill high above the River Wye. The upper image shows the Wye on its approach to the mill and Cressbrook Hall, with its commanding view along the river valley. The lower image shows the mill buildings from Monsal Dale in the nineteenth century, with Cressbrook Hall and Cressbrook village on the hills behind.

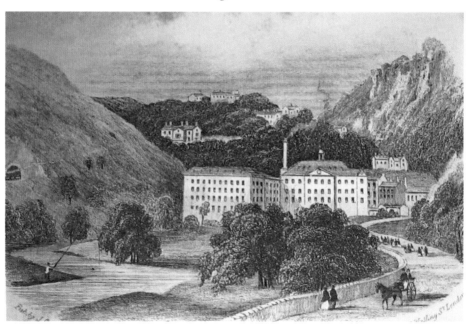

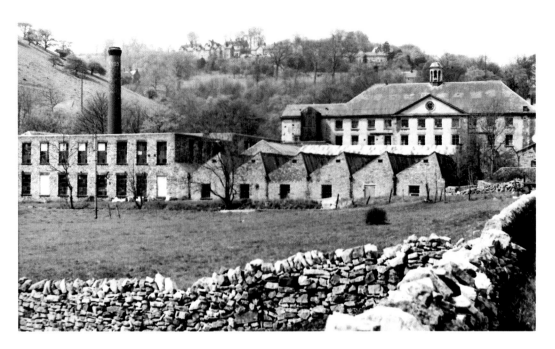

Cressbrook Mill
The upper image shows the mill after its closure in 1971, when it stood derelict for several years. The buildings in the mill complex were restored for residential use in the 1990s. The lower image shows the mill buildings following their restoration and conversion to apartments.

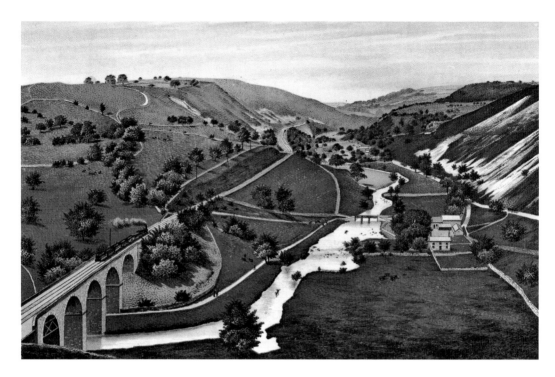

Monsal Dale

The Wye Valley then enters Monsal Dale, a wider dale with two small farms by the side of the river. The dale was much admired by nineteenth-century artists and visitors. The upper image was taken from the viewpoint at Monsal Head, looking back along the river towards Cressbrook, showing the railway viaduct across the river and the farms. The lower image, from a similar viewpoint, shows the scene today, with a major increase in tree cover apparent in the February sunshine.

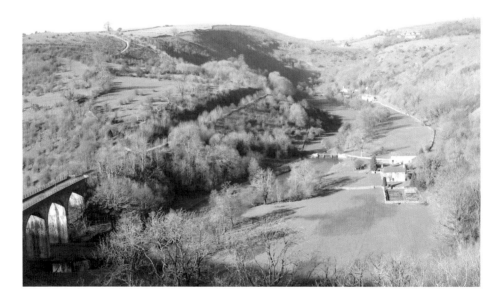

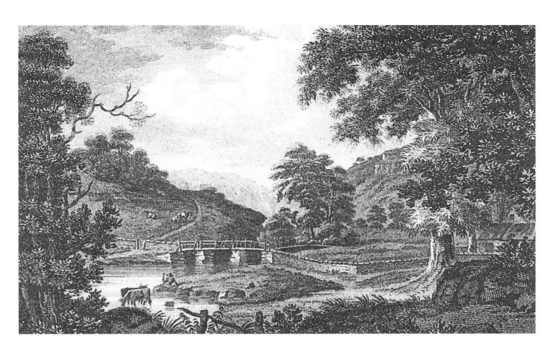

Monsal Dale

The farm nearer to the viewpoint in the pictures on the previous page is Nether Dale Farm. The pictures on this page show the farm, the footbridge and the high rocks above the valley floor, viewed from the riverbank. The road from Monsal Head down into the valley runs past the farms to Cressbrook, giving good views of this pleasant setting.

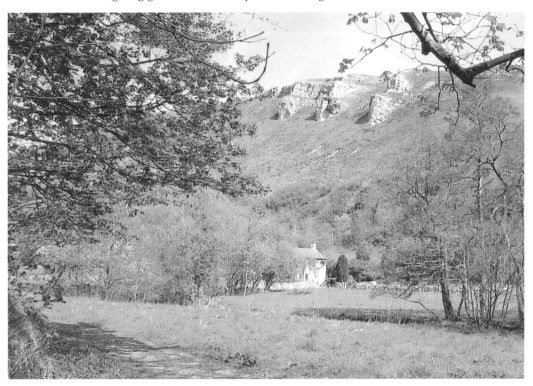

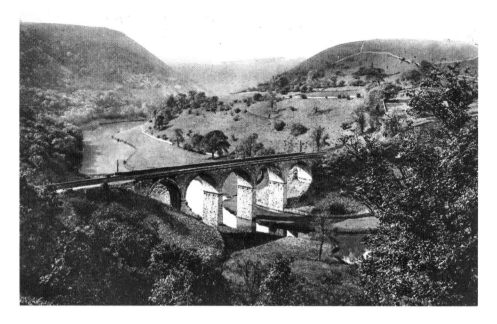

Monsal Dale and Fin Cop

The upper image, also from Monsal Head but looking towards Ashford, shows the river valley after it makes a major change of direction. The hill on the left is Fin Cop, site of an Iron Age fort high above the river. The lower image shows an excavation of the site of the fort, carried out by Longstone Local History Group, which found evidence for the construction of the hill fort around 400 BC. The bodies of nine women and children were found in the ditch where they had been thrown when the ramparts were destroyed at a later date.

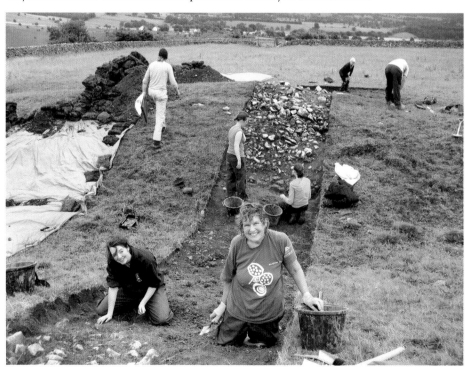

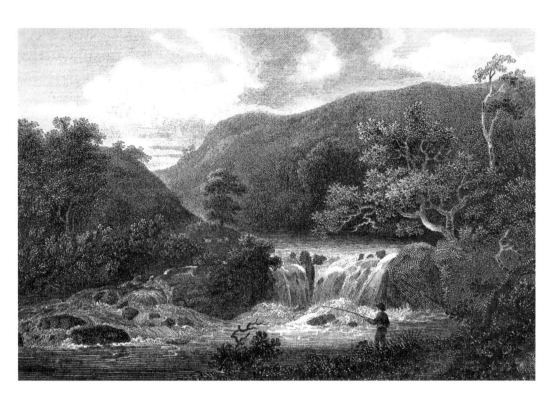

The Weir in Monsal Dale

The famous weir in Monsal Dale is shown in prints and paintings from the 1750s onwards, and it was much admired for its picturesque setting. It seems to have been built as a landscape feature and for angling purposes. At one time, there was a boathouse a short distance up from the weir. It has changed in appearance over the years, but the weir still remains a feature of great interest.

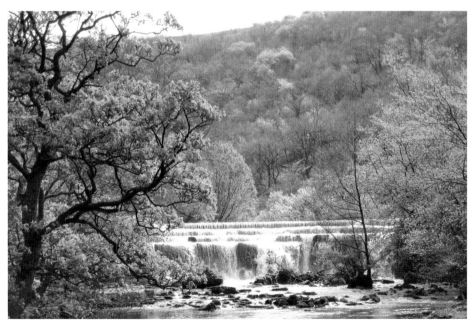

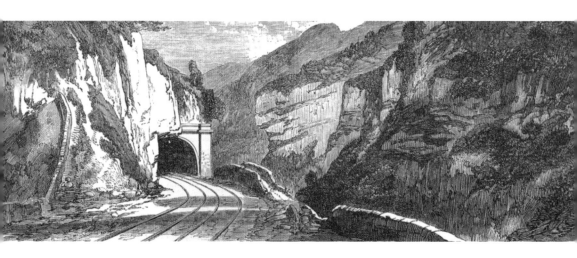

Monsal Trail at Chee Tor

The railway line along the Wye Valley to Buxton finally opened in 1863 and this event was commemorated by an article in the *Illustrated London News* of 13 June 1863, accompanied by four pictures that are reproduced as the upper image on pages 28–31. The pictures were clearly chosen to demonstrate the testing terrain faced by the railway engineers, requiring a succession of tunnels and bridges.

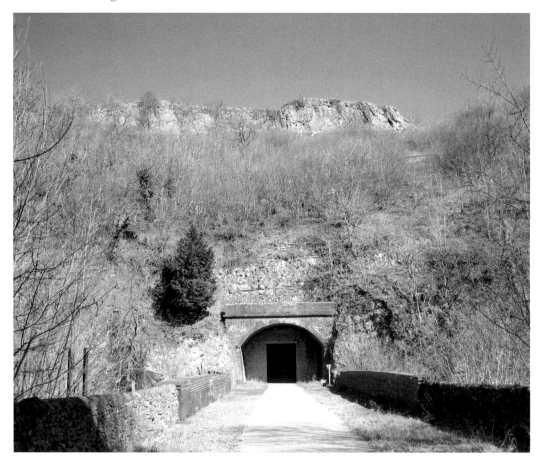

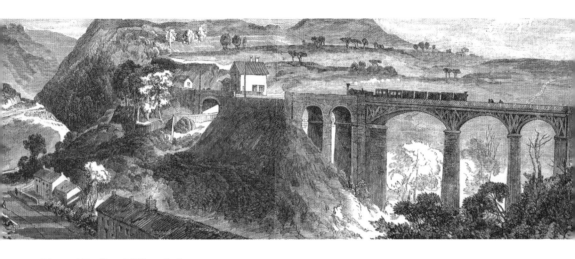

Monsal Trail at Millers Dale

Following the closure of this section of the railway in 1968, the trackbed was purchased by the Peak District National Park and opened as the Monsal Trail in 1981, for walkers, horse riders and cyclists. However, the situation was unsatisfactory because four of the longer tunnels were kept closed for safety reasons. In May 2011, after a substantial investment in lighting and resurfacing, these tunnels were reopened and the Monsal Trail became a continuous 8-mile length from Blackwell Mill to Coombs Road, beyond Bakewell.

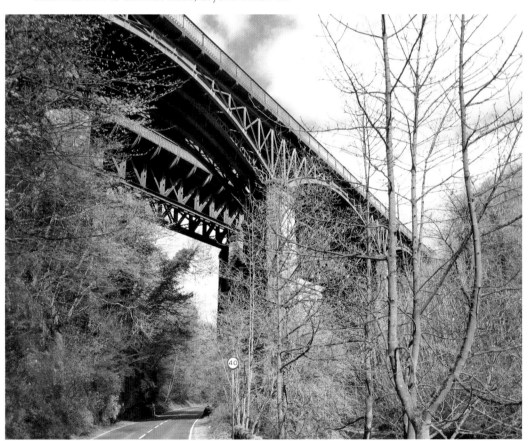

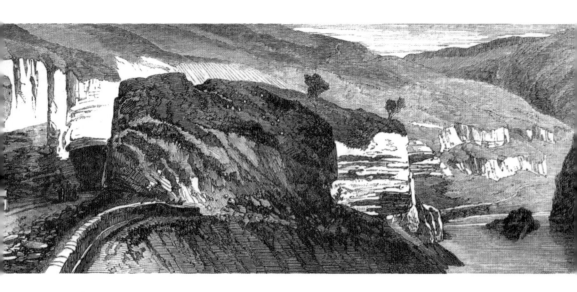

Monsal Trail near Cressbrook

On page 28, the upper image shows a short tunnel on the approach to the main tunnel beneath Chee Tor; the lower image shows the bridge across the river and Chee Tor tunnel before it was reopened. On page 29, the upper image shows Millers Dale station and the long, single bridge across the valley. In 1906, a second bridge was built because freight traffic from the local limestone quarries had increased substantially. The lower image shows the two bridges from road level.

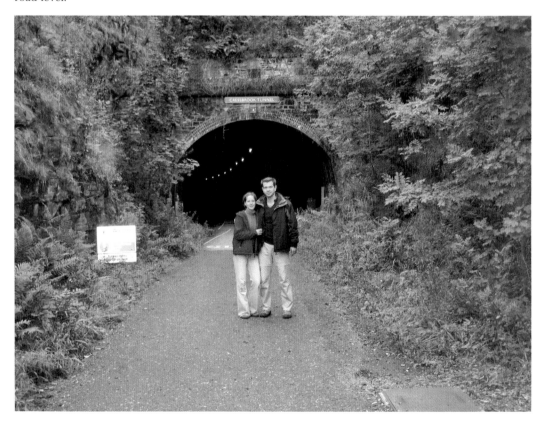

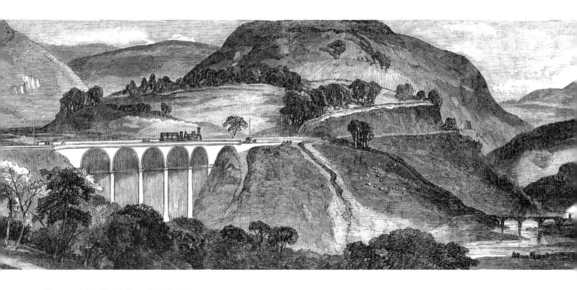

Monsal Trail at the Viaduct

The upper image on the previous page shows the short stretch of open track between the Litton and Cressbrook tunnels, looking back towards Litton Mill, and the lower picture shows the Cressbrook tunnel after it reopened. The images on this page show the famous Monsal Viaduct, from a distant viewpoint, above, and from river level, below, looking up towards Monsal Head.

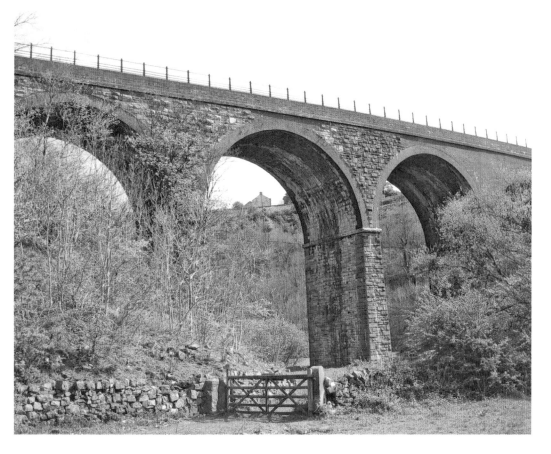

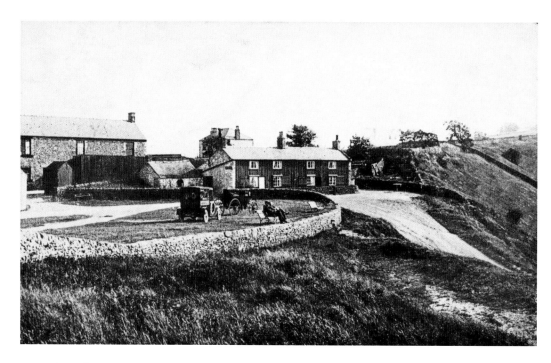

Monsal Head

After the viaduct, the Monsal Trail continues through Headstone tunnel beneath Monsal Head, which is a popular viewing point for Monsal Dale, offering spectacular vistas in both directions. The area is served by car parks, footpaths, a hotel, a craft shop and a café. A minor road descends a steep hill to the pleasant road along the valley to Cressbrook Mill and village.

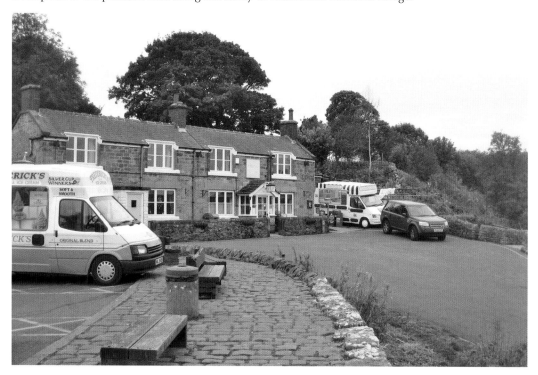

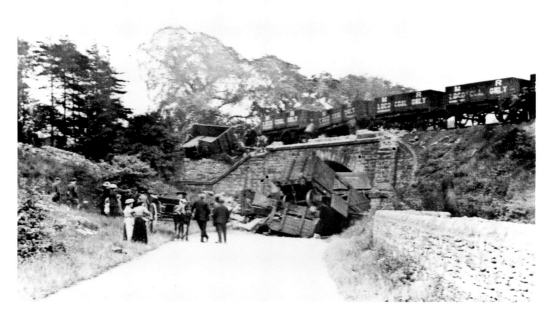

Monsal Trail Towards Bakewell

The upper image shows an accident in 1909 on the line between Longstone and Hassop, small stations after the Headstone tunnel. The lower image shows the railway staff at Bakewell station in the 1920s. At the time of writing, plans are under discussion to extend the Monsal Trail from Coombs Road to Rowsley by reopening the last tunnel, which runs beneath Haddon Hall; such an extension of the trail would be a great achievement.

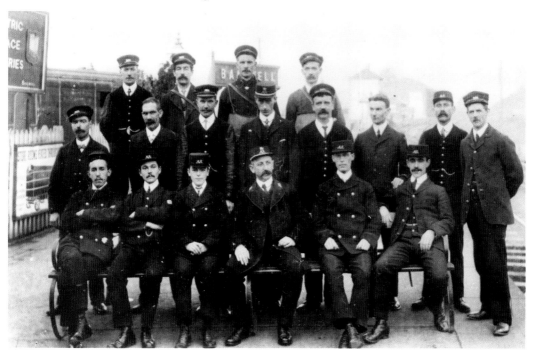

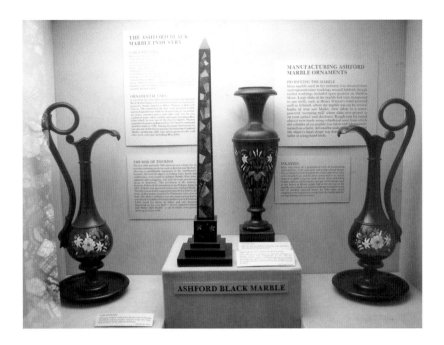

Ashford Marble

Ashford marble is a dark-coloured form of limestone that can be shaped, polished and inlaid with other materials to create decorative objects. It was used in decorative schemes at Hardwick Hall and became popular in the mid-eighteenth century after Henry Watson developed the use of water power to cut and polish the stone in 1748. Three mills were built locally for this purpose. There is a good display of Ashford marble objects in Buxton Museum, seen above. The lower image shows the detail of an inlaid table at the Old House Museum in Bakewell (*see pages 55–57*).

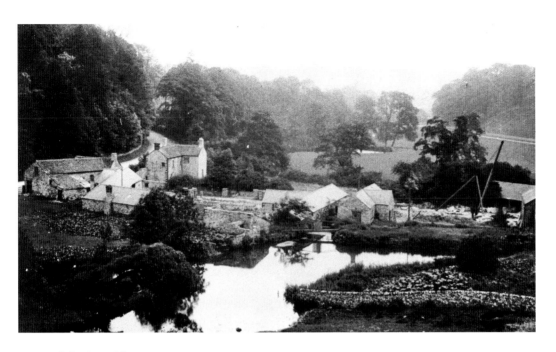

Ashford Marble

The upper picture shows one of the marble mills at Ashford, with separate buildings for cutting, shaping and polishing the stone. The fashion for Ashford marble faded in the late nineteenth century and the mill closed. In 1931, most of the buildings were demolished when a bypass to Ashford village was built across the site. The lower image shows what had been the mill manager's house (also visible in the upper picture) with the new road, named The Duke's Drive, in front of it.

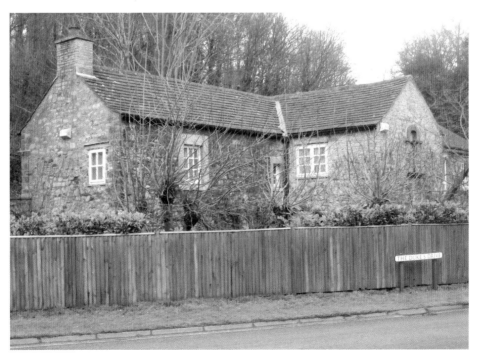

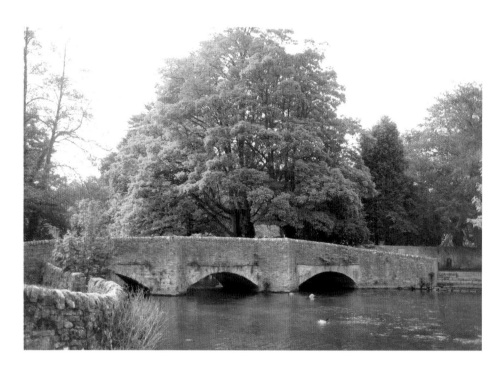

Sheepwash Bridge

The Portway, a long-distance route across the Peak District in Saxon times, crossed the Wye at Ashford, and the settlement is recorded in the Domesday Book of 1086. The Sheepwash Bridge, shown in the upper image, is an ancient bridge near to the line of the earlier ford that gives the village its name. A stonewalled pen by the bridge, used to hold sheep in preparation for washing them in the river, as shown in the lower image, gives the bridge its name.

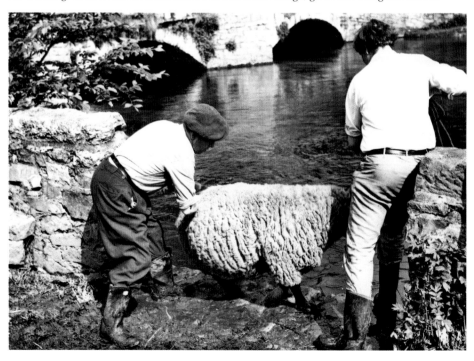

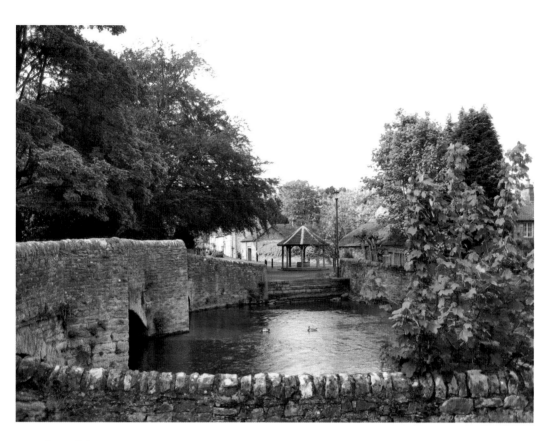

Fennel Street

Ashford has a neat rectangular arrangement of streets, suggesting a planned layout. The upper image looks across the Wye to the structure at the site of one of Ashford's wells, while the lower image looks past that structure along Fennel Street, on the Buxton side of the village.

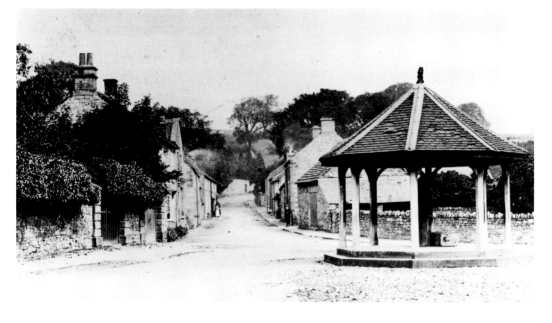

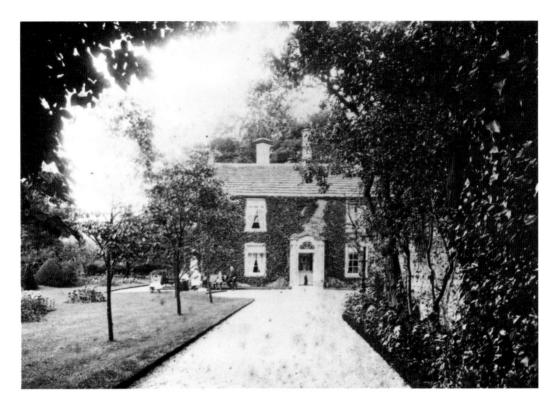

Riverside Hotel

The gateway on the left of the previous picture led to Riversdale House, shown in the upper picture. This house was set in extensive grounds along the banks of the Wye. The property is now the Riverside House Hotel, shown in the lower image.

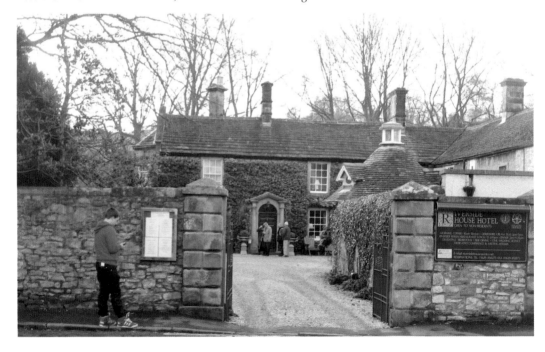

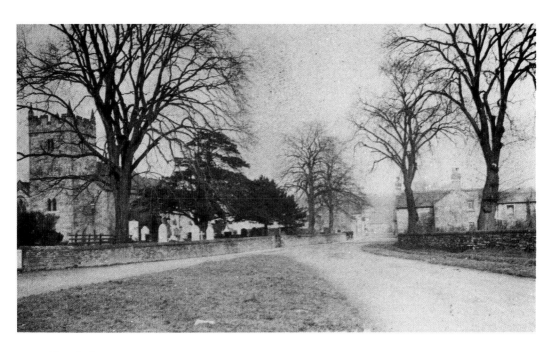

Church Street

The upper image shows Church Street from the corner with Fennel Street, with the church on the left. The lower image shows the church in more detail. Holy Trinity church dates back to the thirteenth century in part, with a fourteenth-century tower and font. It was largely rebuilt in the 1870s.

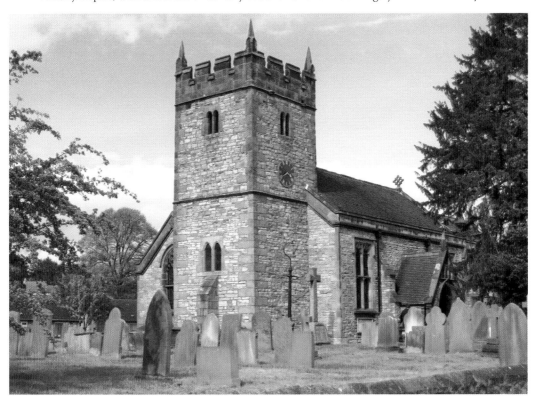

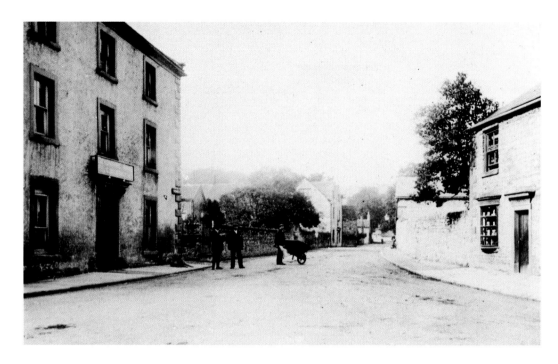

Church Street

The upper image shows Church Street looking back towards Fennel Street. The building on the left is one of the village pubs, then called the Devonshire Arms, an eighteenth-century coaching inn. In the lower image, the pub is now called the Ashford Arms. Across the road is Ibbotson's, the busy village shop and delicatessen, with a wide range of fresh foods.

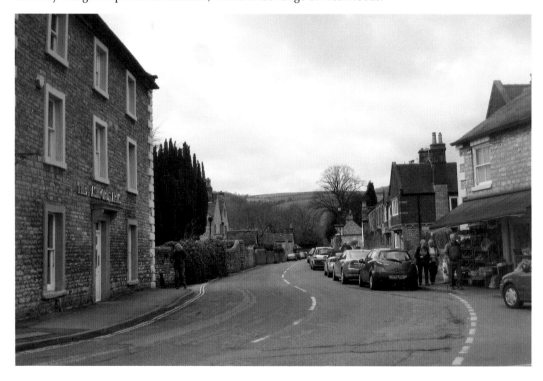

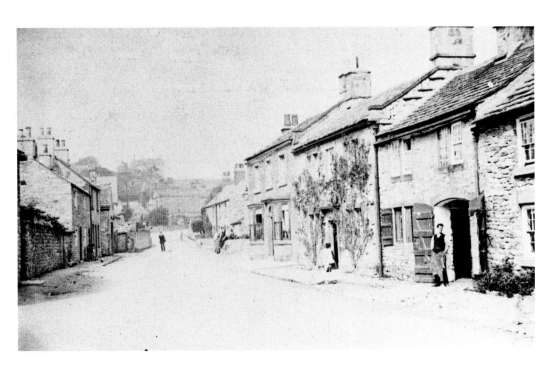

Greaves Lane

Around the corner from Church Street, Greaves Lane, like the other roads in Ashford, has an interesting array of well-maintained stone-built cottages, some with names indicating their earlier uses, including the smithy and the candle maker's cottage. The name 'greaves' means 'drops of melted tallow' – a by-product of candle making.

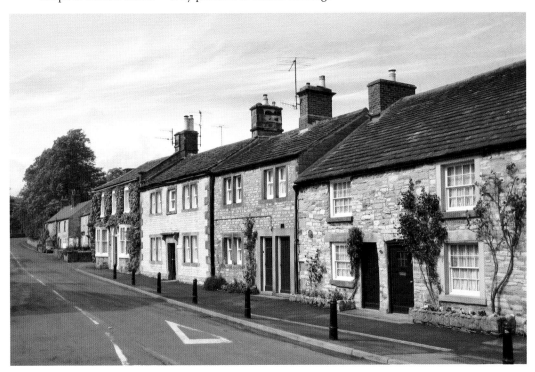

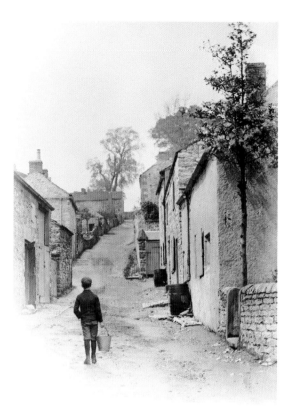

Hillclose

At the top of Greaves Lane, the road divides. Hillclose, a narrow lane of stone-built cottages, leads uphill to the left, while the larger road leads uphill to the right, on the way to Monsal Head and Wardlow.

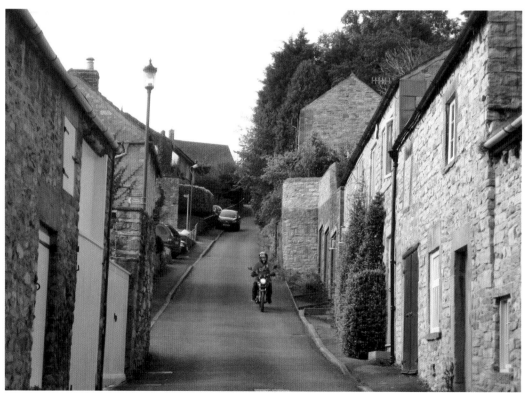

Well Dressing at Ashford

The Derbyshire custom of 'well dressing' is particularly important in Ashford. This custom, with very ancient origins, is an observance of the importance of clean supplies of drinking water. Decorative panels, consisting of a bed of clay with a picture created by impressing flower petals into the clay, are sited at the wells. For Ashford's well dressing, five wells are usually decorated and displayed for a week close to Trinity Sunday.

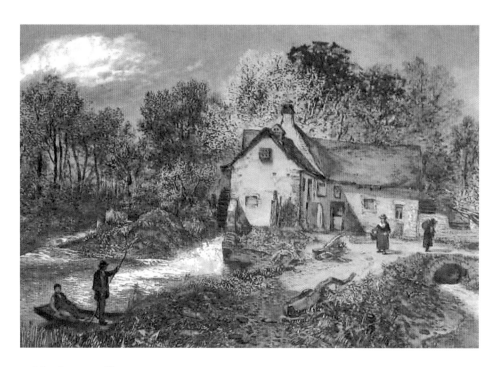

Ashford Corn Mill

The medieval corn mill was located on the opposite bank of the Wye, a short distance from the village, with an imposing millstream leading to it. The present mill building dates in part from the sixteenth century. It continued in operation until the 1970s, and its nineteenth-century water-powered electricity generator has recently been restored. The nearby bridge over the millstream is dated 1664.

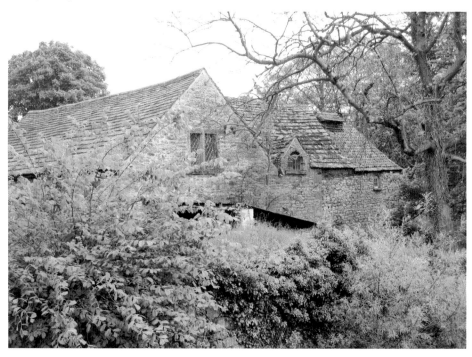

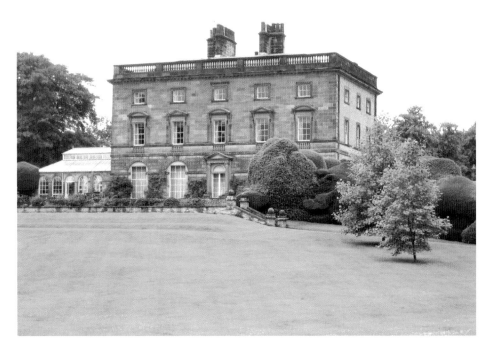

Ashford Hall

Ashford Hall, on the Bakewell side of the village, is an imposing eighteenth-century building, constructed in 1785 in the Classical style and set in pleasant grounds. It borders on to Ashford Lake, seen in the lower image, which is a stretch of the River Wye with its level raised by a large weir further downstream, creating an attractive landscape feature complete with boathouse.

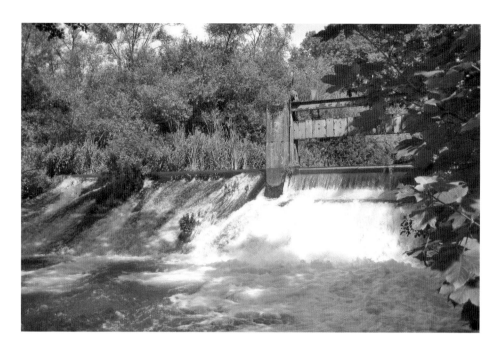

Lumford Mill

In addition to its landscape features, Ashford Lake was also a reservoir for the Lumford cotton mill a short distance away on the edge of Bakewell. The upper image shows the main weirs built to create Ashford Lake (left) and to control the water flow to Lumford Mill (right), as seen from the footpath between Ashford and Bakewell. The lower image shows the water channel, now no longer in use, as it approaches the mill. The upper image on the following page shows the large waterwheels powered by the flow from this channel. They were installed in 1827.

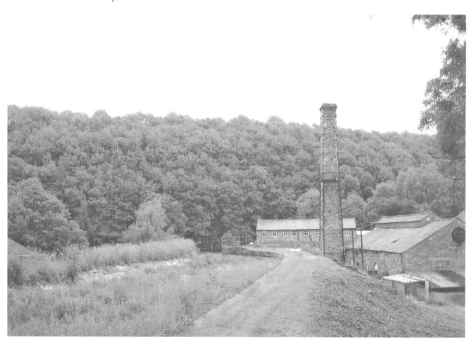

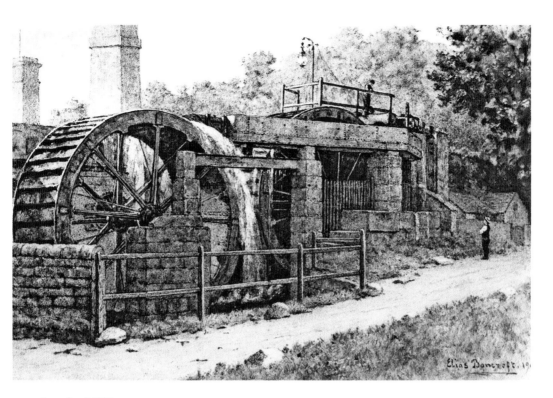

Lumford Mill

Lumford Mill was built by Sir Richard Arkwright in 1778, following the success of his two mills at Cromford. It was originally powered from a reservoir close to the mill, with the water flowing through an arched channel beneath the mill building. In 1868 the main building was destroyed by fire, making 300 workers unemployed. The lower image shows the ruined building following the fire. There is an interesting display relating to Lumford Mill at the Bakewell Old House Museum (*see pages 55–57*).

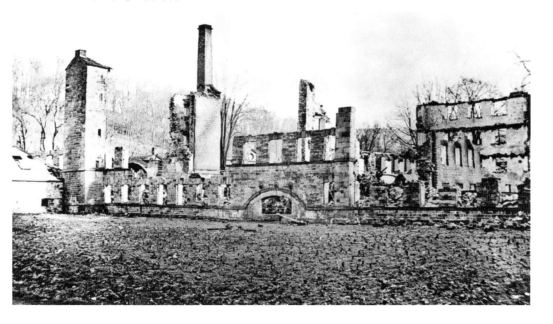

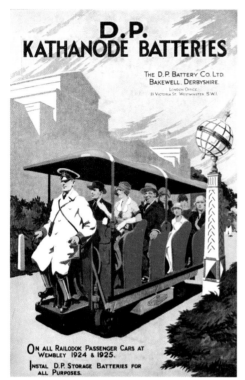

D.P. KATHANODE BATTERIES

THE D.P. BATTERY CO. LTD.
BAKEWELL. DERBYSHIRE.

London Office.
11 Victoria St. Westminster S.W.1.

ON ALL RAILODOK PASSENGER CARS AT
WEMBLEY 1924 & 1925.

INSTAL D.P. STORAGE BATTERIES FOR
ALL PURPOSES.

Lumford Mill

The mill was partially rebuilt after the fire, but in the early twentieth century it went out of business. The buildings were then used for the manufacture of electric power storage batteries. The DP Battery factory continued to manufacture batteries for use in vehicles, submarines and stationary installations, as illustrated in the upper image. It closed in June 1970, again with the loss of around 300 jobs. The site is now the Riverside Business Park, home to many local businesses.

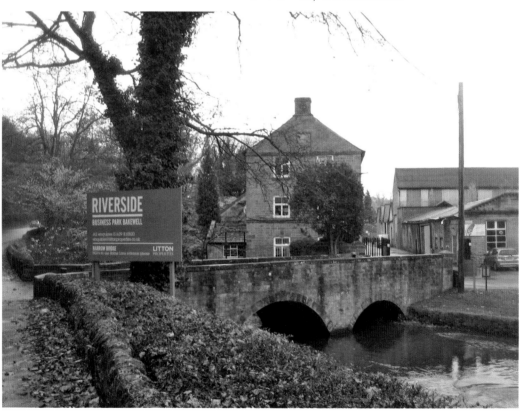

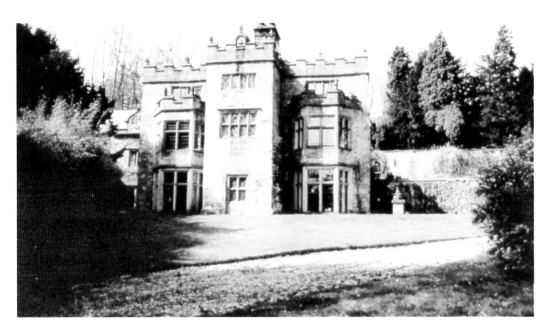

Holme Hall

Holme Hall, seen in the upper image, was built in 1626 for Bernard Wells, a lead merchant; an older part of the building can be seen to the left of the 1626 building. It stands in attractive landscaped grounds, a short distance downstream from Lumford Mill. The packhorse bridge, pictured below, was built in the traditional local style in 1666 to replace an earlier wooden bridge along a route leading past Holme Hall towards the Longstones.

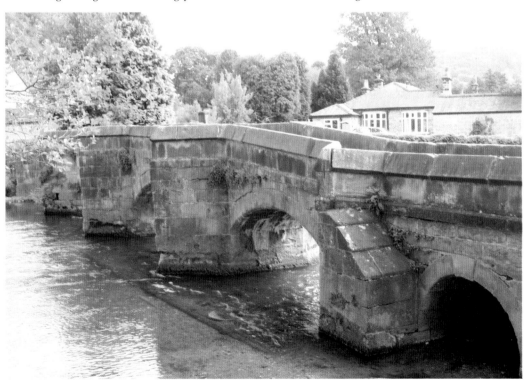

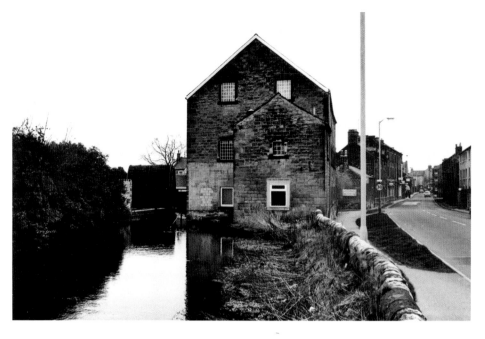

Victoria Mill, Bakewell

Bakewell's medieval corn mill stood on the site of Victoria Mill, and the present building was erected in the early 1800s. It continued in operation as a mill until 1939, and the building has recently been converted to apartments. The mill wheel was removed from the wheel pit and stood by the side of the building for several years, as seen above. The framework of the wheel was restored and located in its present position, seen below, when the modernisation of the building took place.

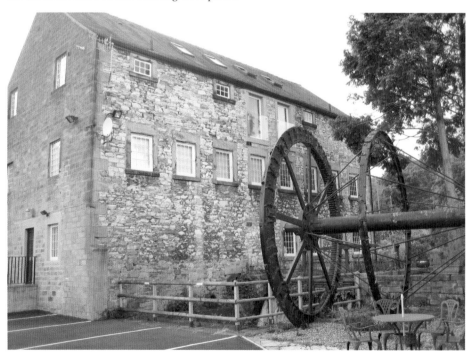

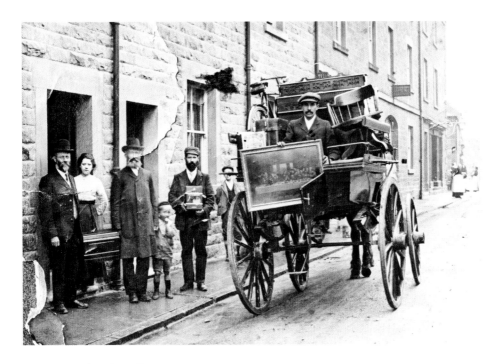

Buxton Road, Bakewell

The road past Victoria Mill on the previous page is Buxton Road (formerly Mill Street), which leads down to North Church Street in central Bakewell. The upper image, dating from around 1904, shows bailiffs seizing possessions from a house in Mill Street for non-payment of rates, during a protest against the use of money from rates being used in support of church schools. The lower image shows cottages in Arkwright Square, a nearby turning off Buxton Road, which were built to house the workers of Lumford Mill.

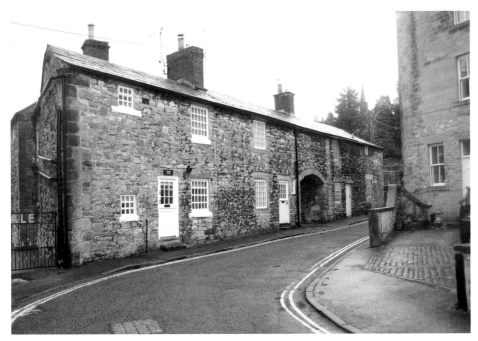

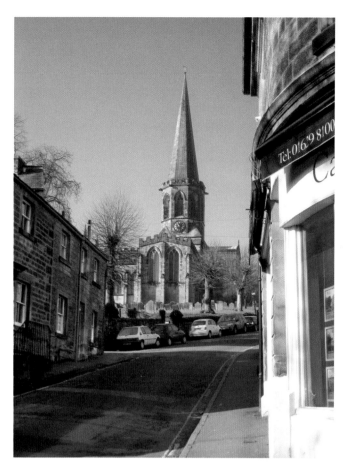

All Saints Church

The upper image, taken from the corner of North Church Street and Buxton Road, shows All Saints church in its prominent position high above central Bakewell. The spire of the church is widely visible across Bakewell and the surrounding area. A church has stood on this site since Saxon times, with several rebuildings. The current church has many important historical features both internally and externally, including a fine display of pre-Norman stone sculptures.

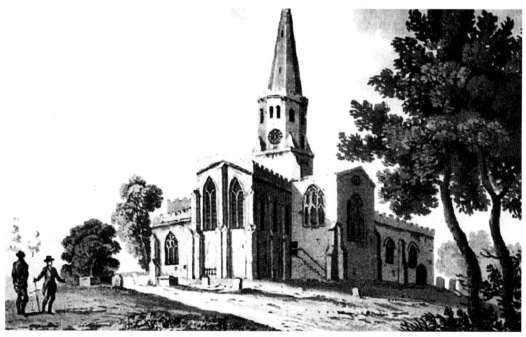

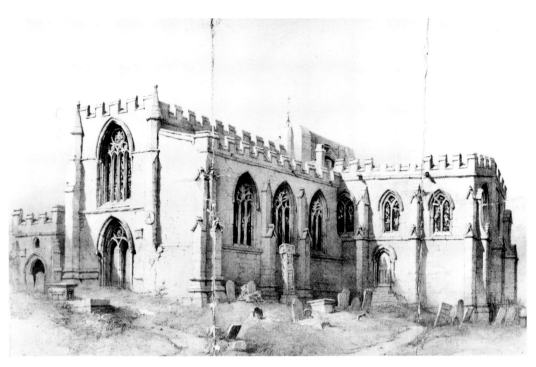

All Saints Church

One particularly important rebuilding took place in 1825, when the church spire (*lower image, page 54*) was found to be in danger of collapse and had to be demolished. To the dismay of the townsfolk, the church stood without a spire for a time (as it appears in the upper image), while several alternative designs for its replacement were considered. It was not until 1841 that work began on the present spire, which is 16 feet shorter than its predecessor It is shown in the lower image, taken from South Church Street.

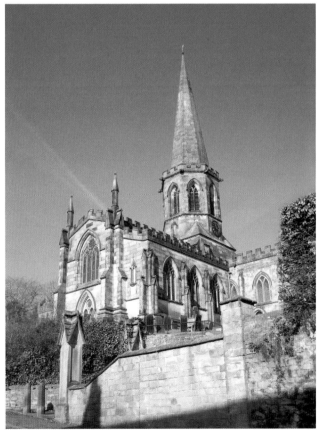

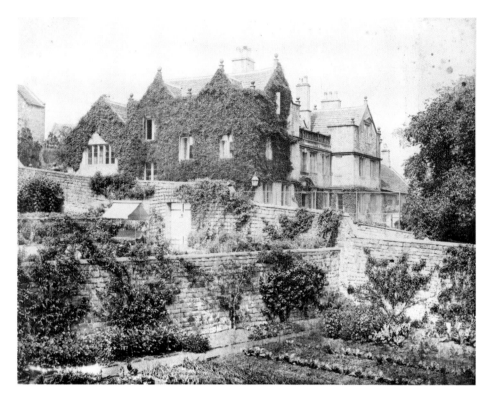

Bagshaw Hall

Bagshaw Hall is a large house built in 1686 for Thomas Bagshaw, the Duke of Rutland's agent, with stables and extensive gardens surrounded by a high boundary wall. It is on a prominent site, close to the church and with extensive views across the Wye Valley. The building now provides accommodation for visitors in a variety of suites and apartments.

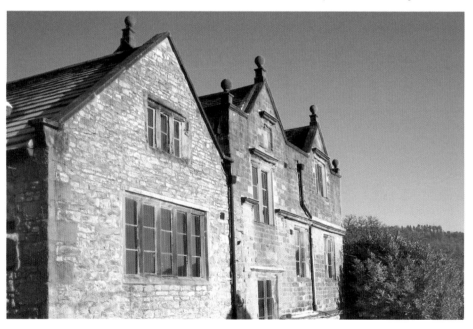

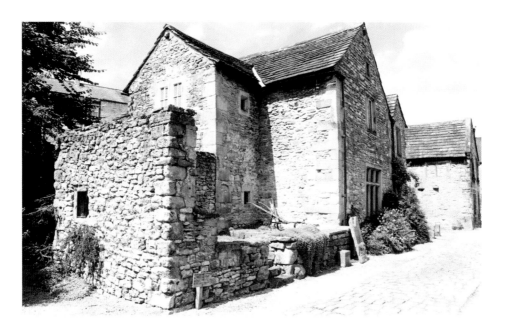

Bakewell Old House Museum

The old house shown in the upper picture, located a little uphill from the church, was built in 1534 as a tithe collector's house for the Dean and Chapter of Lichfield. It is the oldest house in Bakewell. It has had many uses over the years, but became derelict and was threatened with demolition in the 1950s. It was rescued and restored by the Bakewell & District Historical Society in 1954 and later opened as the Bakewell Old House Museum. The museum has a wide range of displays relating to Bakewell and the surrounding rural area.

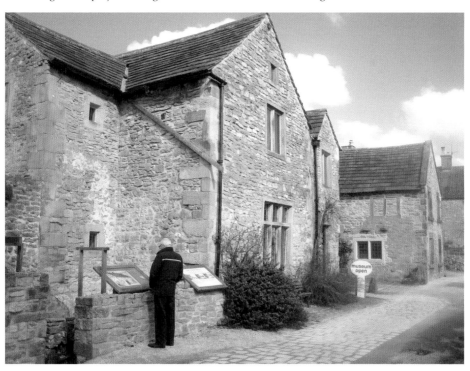

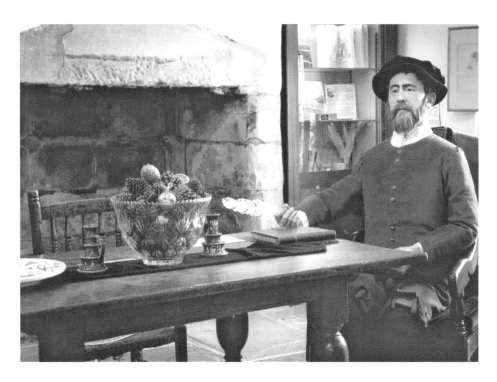

Bakewell Old House Museum

Some of the museum displays relate to living and working conditions at different times, such as the sixteenth-century steward waiting to receive rents and tithes, above, and the Victorian kitchen typical of a millworker's cottage, below. Other displays include many interesting personal items such as crockery, tools and toys donated by local volunteers.

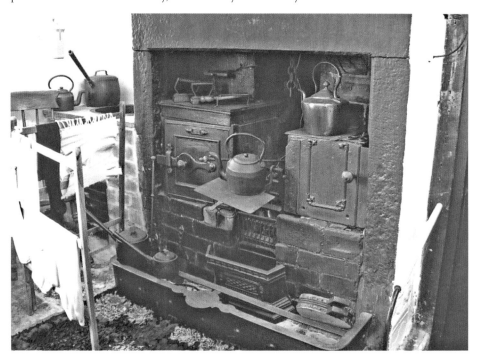

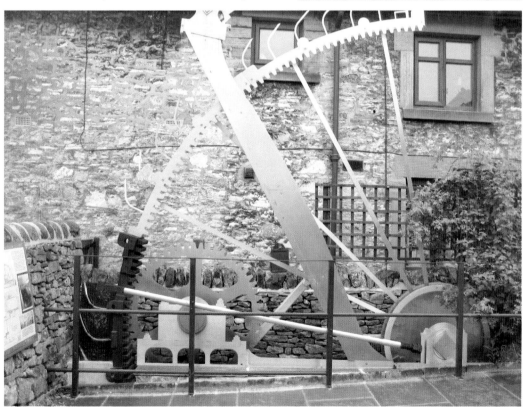

The Arkwright Connection

Sir Richard Arkwright converted the Old House into five small dwellings for millworkers at Lumford Mill (*see pages 46–48*), which was the third of Arkwright's mills, following his two mills at Cromford. These ventures drove the change of the textile industry from a cottage-based to a factory-based industry. The museum illustrates some of these changes: the upper image shows a small spinning wheel for producing linen thread from flax, and the lower image shows part of the display on the waterwheels that provided 100 horsepower for the machinery at Lumford Mill after 1827.

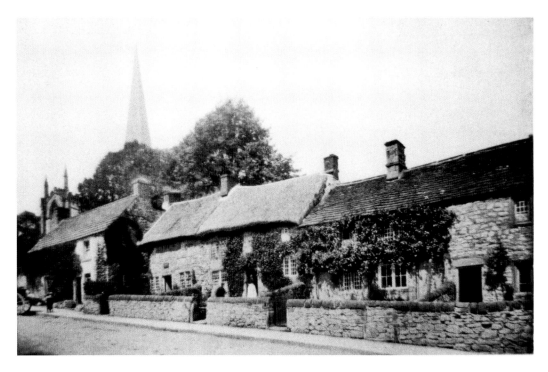

South Church Street

On the other side of the churchyard, South Church Street has an interesting selection of old stone-built houses. The upper image shows a row of old cottages, some with thatched roofs, which are thought to have been the last cottages in Bakewell to switch to tiled roofs. The lower image shows the same location as it is today.

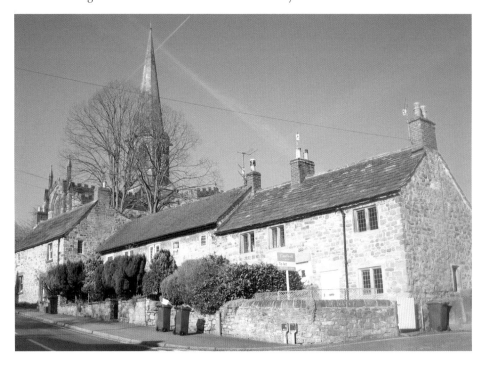

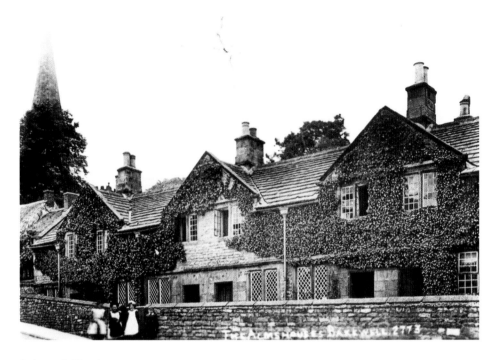

Bakewell Almshouses

These almshouses are located just down South Church Street from the cottages shown on page 58. The original almshouses were founded in 1602, but their present building, shown in the upper picture, dates from 1709. The building originally provided six small homes, but it became derelict and was closed in 2001. After a major restoration, the almshouses were reopened in 2006 as three larger homes.

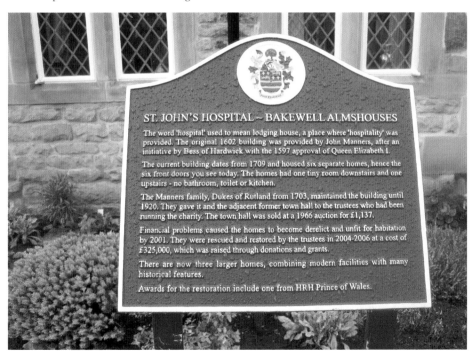

ST. JOHN'S HOSPITAL ~ BAKEWELL ALMSHOUSES

The word 'hospital' used to mean lodging house, a place where 'hospitality' was provided. The original 1602 building was provided by John Manners, after an initiative by Bess of Hardwick with the 1597 approval of Queen Elizabeth I.

The current building dates from 1709 and housed six separate homes, hence the six front doors you see today. The homes had one tiny room downstairs and one upstairs - no bathroom, toilet or kitchen.

The Manners family, Dukes of Rutland from 1703, maintained the building until 1920. They gave it and the adjacent former town hall to the trustees who had been running the charity. The town hall was sold at a 1966 auction for £1,137.

Financial problems caused the homes to become derelict and unfit for habitation by 2001. They were rescued and restored by the trustees in 2004-2006 at a cost of £325,000, which was raised through donations and grants.

There are now three larger homes, combining modern facilities with many historical features.

Awards for the restoration include one from HRH Prince of Wales.

King Street

The upper image shows the old town hall building (contemporary with the almshouses), located at the sharp change in direction where South Church Street meets King Street. It has had many uses over the years – town hall, fire station, school and shop. The lower image shows Kings Court, an old courtyard now housing several small shops and a café, as King Street leads down to Matlock Street.

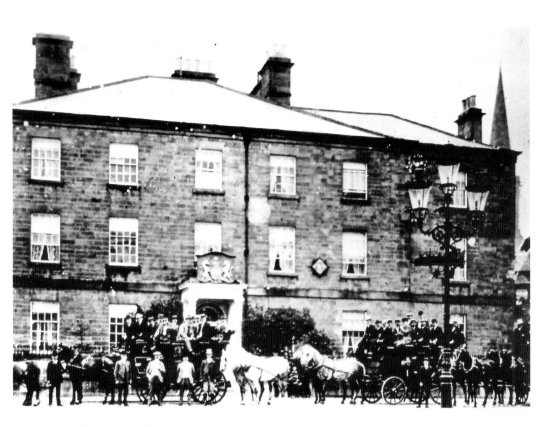

Rutland Arms Hotel

The Rutland Arms Hotel lies between North Church Street and King Street, forming one side of Rutland Square. The present building dates from 1805, when it replaced the White Horse Inn. In the lower picture, from 1923, the war memorial has replaced the ornate light standard shown in the upper image. The building on the left, with the three pointed gable ends, was known as the Clothing Hall, originally a location for the wool trade.

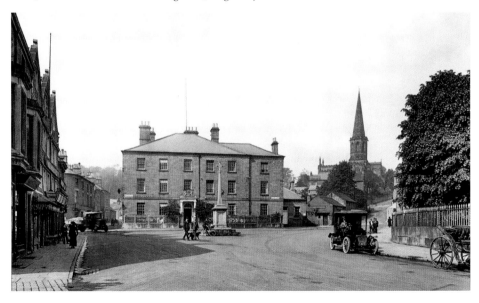

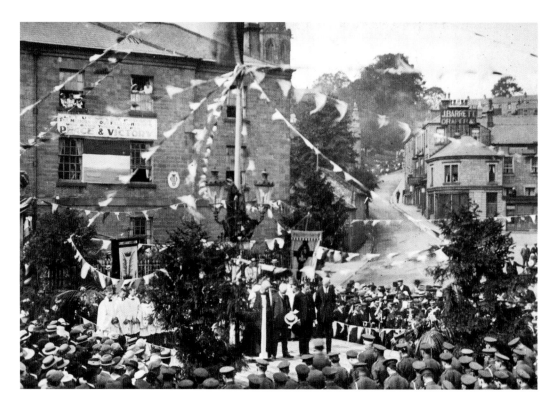

Ceremonies and Celebrations

Rutland Square leads into Bridge Street, and together they form a natural forum for large-scale events in Bakewell. The upper image shows the Armistice Day commemoration service of 1919, in front of the Rutland Arms Hotel, before the war memorial was erected. The lower image shows the Olympic flame relay passing through Bakewell in June 2012. Andrew Marriot, on the left, is passing the flame to local resident Frances Dalrymple-Smith at the bottom of Bridge Street.

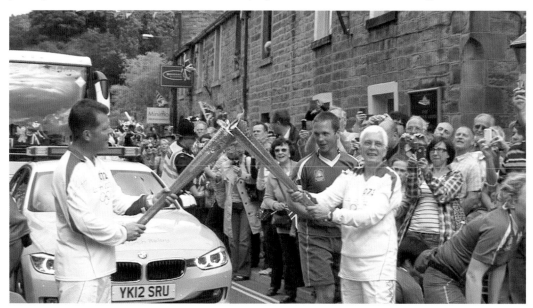

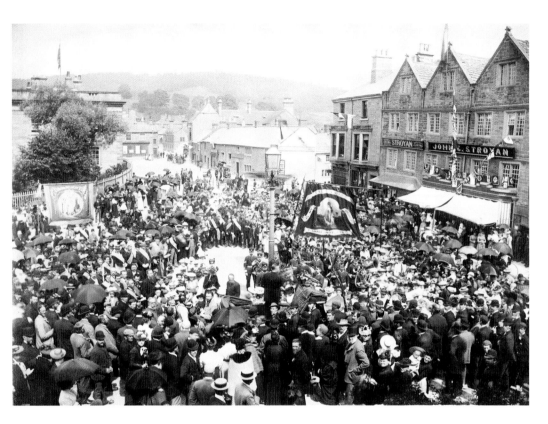

Ceremonies and Celebrations

The upper picture, from the 1890s and taken from the Rutland Arms Hotel looking down towards Bridge Street, shows a public gathering to celebrate a visit by the Duke of Rutland. The lower image, taken from a similar position, shows the Olympic flame, still in the hands of Frances, passing through Rutland Square, with Bath Gardens on the left. The Clothing Hall, on the right of the upper image, was rebuilt in 1936 to provide retail premises, maintaining a similar façade, as seen in the lower image.

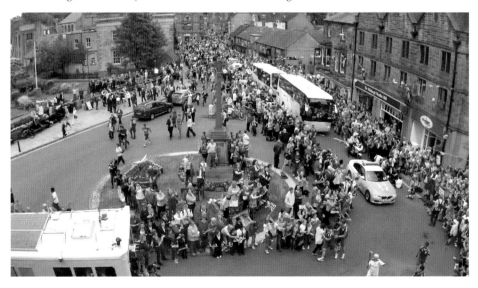

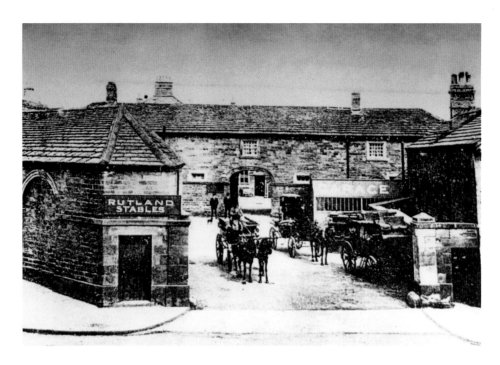

The Stables

The stables for the Rutland Arms Hotel, seen above, were built across the road, on an adjacent side of Rutland Square. Part of these buildings now houses the Bakewell Antiques Centre, below, with an interesting selection of antique businesses under the one roof.

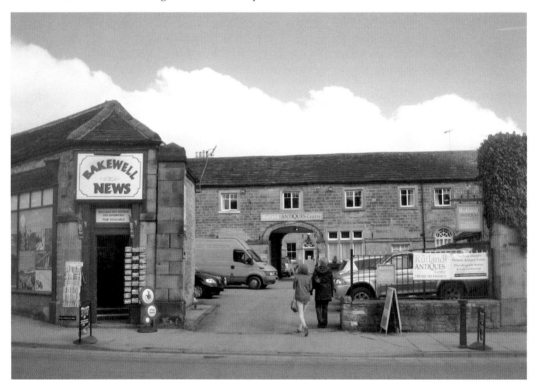

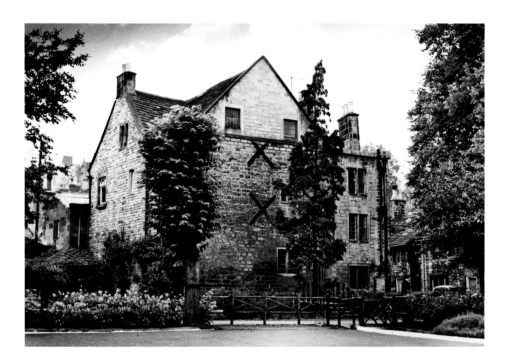

Bath Gardens

The town well for Bakewell was located in Bath Street (behind where the stables block now stands) and around 1700 the Duke of Rutland built the Bath House, seen in the upper image, over this well, to create a rival attraction to the neighbouring spas. It was not a successful venture, but the covered bath still remains. Bath Gardens, between Bath Street and Rutland Square, is an attractively laid-out green space in the middle of Bakewell, which replaced earlier buildings when Rutland Square was created.

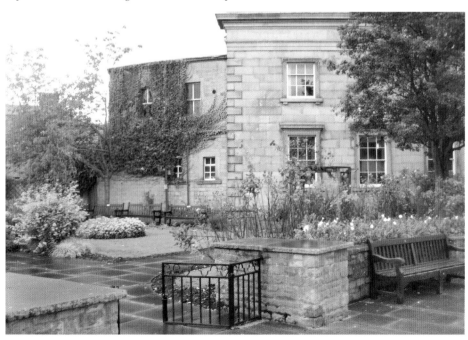

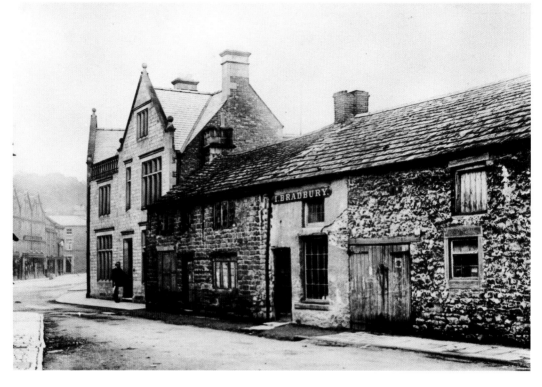

Bakewell Town Hall

In the 1890s, Bakewell saw two major public buildings erected near where Rutland Square meets Bridge Street. The upper image shows the cottages on the site where Bakewell town hall would be erected in 1890, adjacent to the imposing house of Andrew Cokayne (a local antiquary and art collector), with Rutland Square beyond. The lower image shows the new town hall (looking past Cokayne's house from the Rutland Square side) with a smaller building across the road, which housed Critchlow's store.

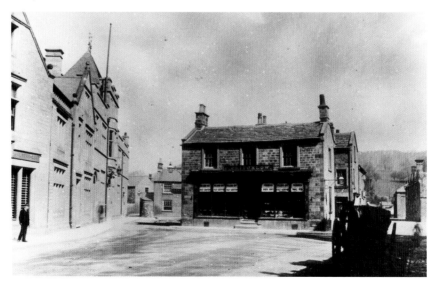

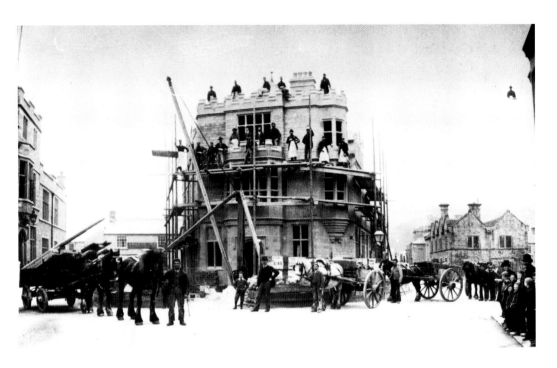

The Post Office Building

In the upper picture, the town hall can be seen on the left. Critchlow's shop has been demolished and the site is now occupied by the new post office building, in the final stages of construction. It opened in 1894. The lower picture shows the completed town hall and post office as they are today. The post office has moved elsewhere and that building is occupied by shops and offices.

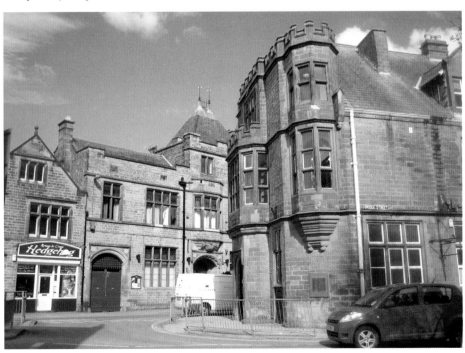

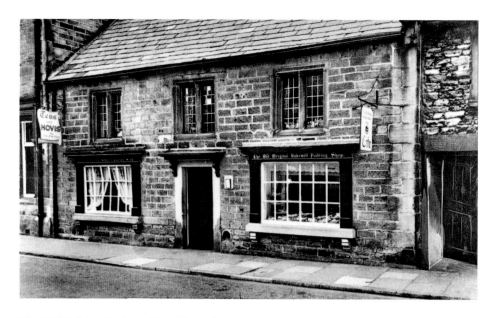

The Old Original Bakewell Pudding Shop

Bakewell has achieved widespread fame as the home of the Bakewell Pudding. The Old Original Pudding Shop, located in a seventeenth-century stone cottage in Bridge Street, has been making Bakewell Puddings since the nineteenth century. In 1987, there was a Festival of National Parks held at Chatsworth and the lower image shows a Bakewell Pudding made for this event. It weighed six hundredweight!

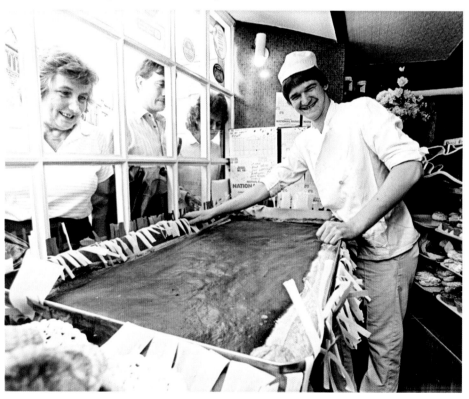

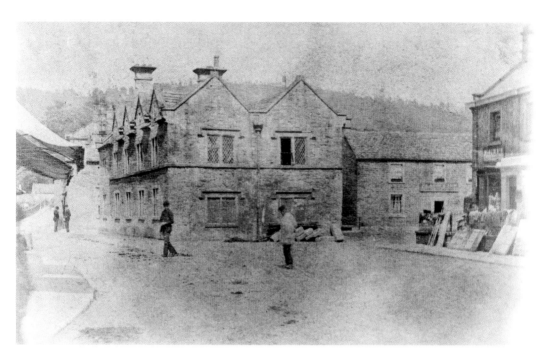

The Market Hall

Markets have been an important part of Bakewell life since the thirteenth century. At the centre of a large rural area, Bakewell has had livestock and produce markets at different sites in the town since that time. The market hall in Bridge Street was built in the early seventeenth century and the upper image, dating from the nineteenth century, shows the building looking from Rutland Square. The lower image shows a more recent view, from a similar viewpoint, with the windows removed from the upper level of the end wall and a shopfront occupying the lower level.

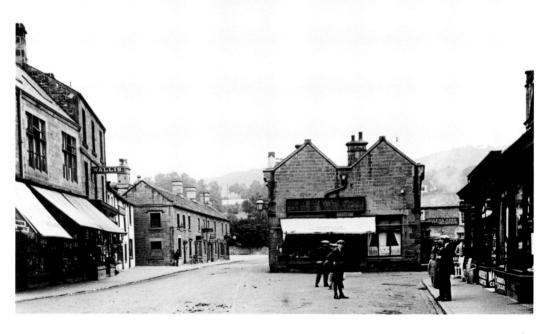

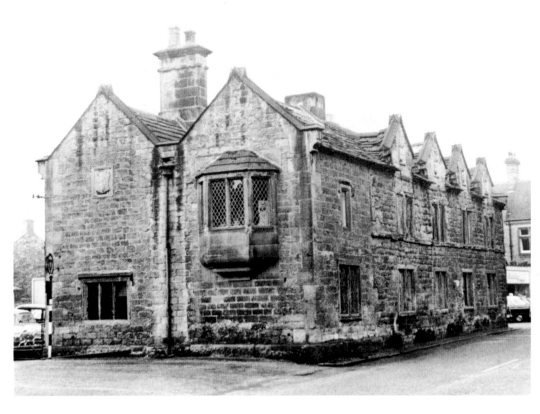

The Market Hall

The upper picture shows the market hall looking from Bridge Street towards Rutland Square. The lower image shows the building today, largely unchanged from this angle apart from the removal of some chimneys. The building is now used as a visitor centre for the Peak District National Park.

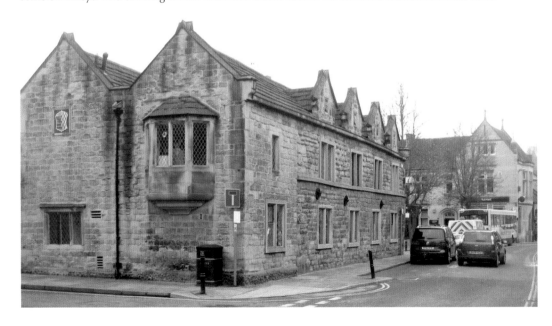

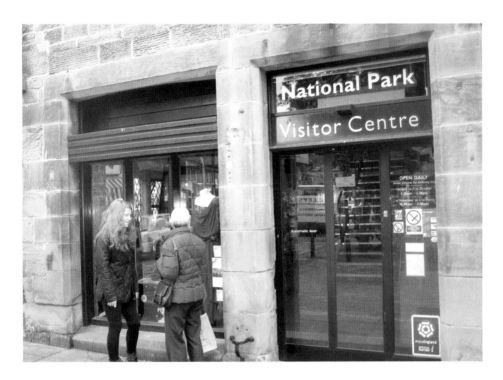

Peak District National Park

The Peak District National Park was established in 1948, the first national park in Britain, and it located its headquarters at Aldern House in Bakewell. Since that time, the national park has played an important part in balancing the conservation, tourism and economic development interests of the area. The visitor centre in the historic market hall has interesting window displays and a vast amount of local information inside for the visitor.

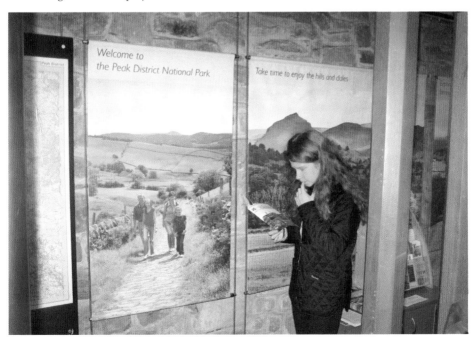

The Stalls Market

The large open space on the other side of the market hall has been home to a busy market for many years. Held throughout the year on Mondays, this thriving weekly market has over sixty stalls on the Market Square and Granby Street.

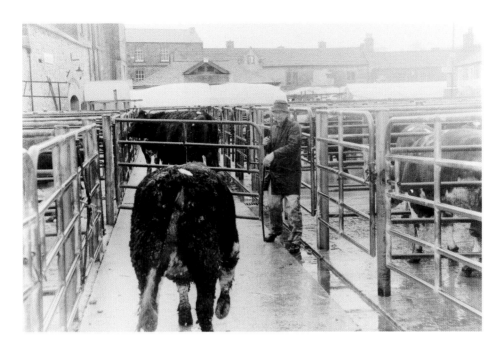

The Livestock Market

Until the early 1800s, the livestock markets in Bakewell took place each Monday on the streets around what is now Rutland Square. The Duke of Rutland then built pens and an auction area for the livestock markets in Granby Street, which made life easier for the town. However, as the market got busier and vehicles got larger, this caused chaos in Bakewell on market days, and in 1999 the livestock markets were moved to new premises across the river as part of 'Project Bakewell'.

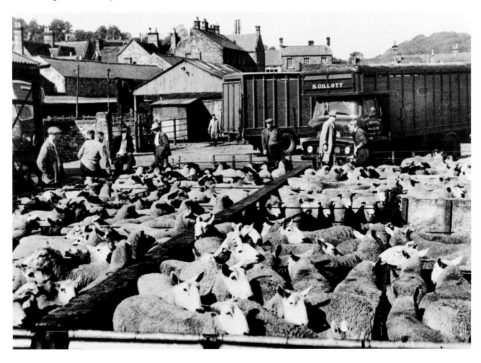

'Project Bakewell'

'Project Bakewell' was developed in the early 1990s to address some of Bakewell's problems, in particular market day congestion and a shortage of modern shopping facilities. The livestock markets were moved to a new site (*see pages 82/83*) and the space released between Market Square and Granby Road was redeveloped with a supermarket, other medium-sized shops, houses and apartments. A swimming pool and a new public library building were included in the town centre development.

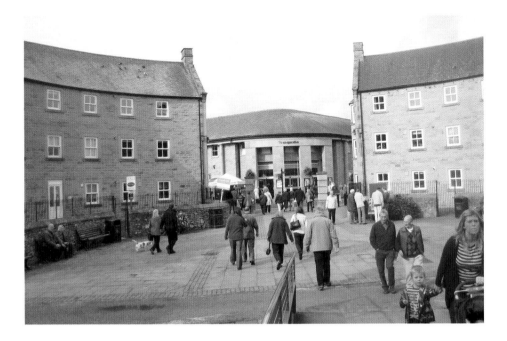

The New and the Old

On page 74, the upper image shows the new buildings on the corner of Granby Road and Matlock Street, while the lower image shows market stalls at the other end of Granby Road, adjacent to the new supermarket. On this page, the upper image shows the arc of new housing on the way to the supermarket from the footbridge across the Wye, while the lower image shows one of the several old streets between Bridge Street and Granby Road, with small specialist shops that thrived as visitor numbers increased following the redevelopment.

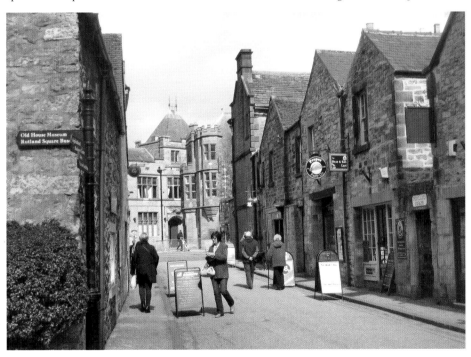

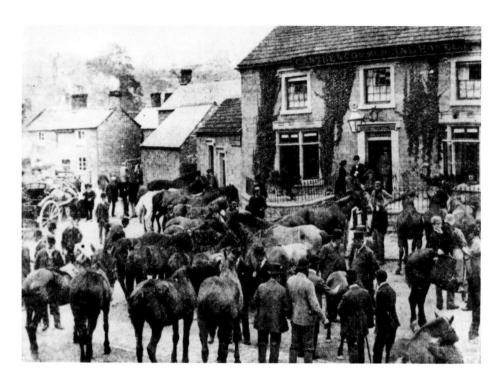

Bridge Street

The upper image shows a horse fair outside the Castle Inn, Bridge Street, in 1910 – one can imagine the scene when cattle and sheep markets also took place on the streets 100 years earlier! The lower image shows Castle Inn today, on the corner of Castle Street.

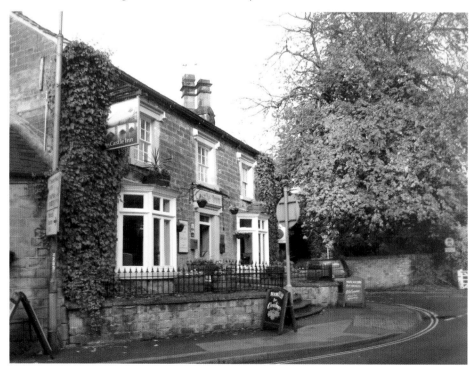

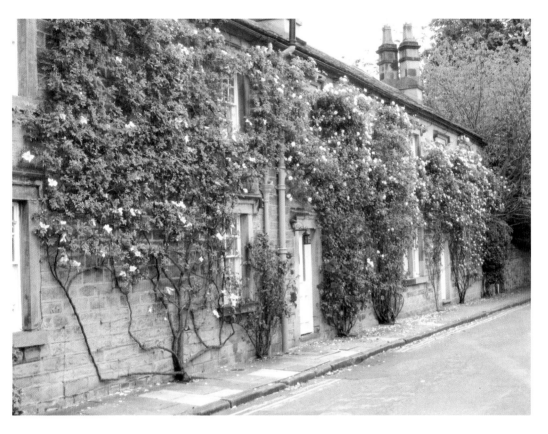

Castle Street and the Bridge

The upper image shows the well-maintained and picturesque nineteenth-century cottages in Castle Street. Just beyond is the famous bridge across the Wye, shown below. Originally, this bridge would have been similar to Holme Bridge (*see page 49*) but it was widened on the upstream side in the 1850s.

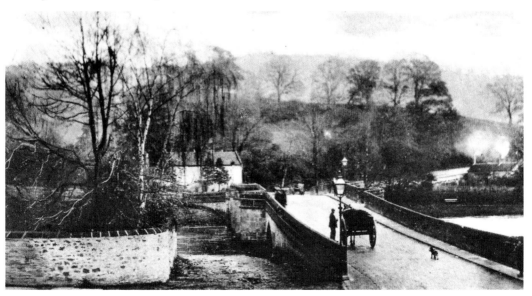

Bakewell Bridge

The upper image, taken from Castle Hill in 1852, shows the bridge at Bakewell, with Bridge Street leading to the town centre. Bakewell church can be seen on the high ground beyond the centre, with Bagshaw Hall to the right, giving a good idea of the town's layout. The lower image shows Bakewell Bridge, with its sturdy stone-built arches that date back many hundreds of years.

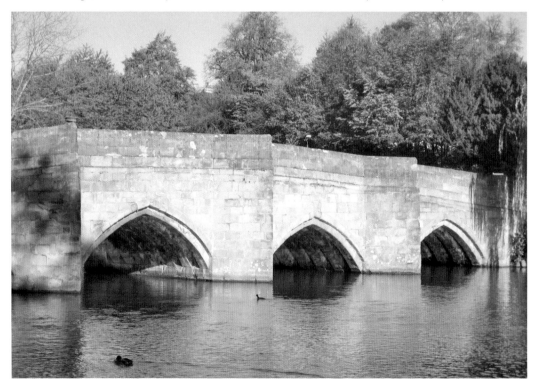

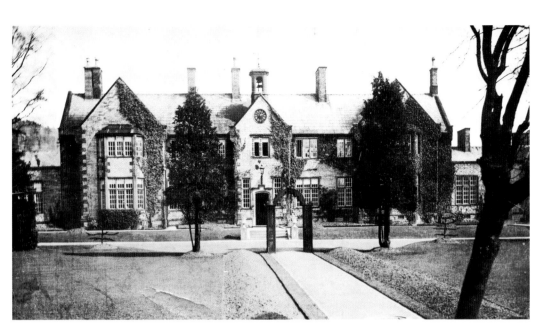

From Workhouse to Hospital

Several important sites are located on the side of the river away from the town centre. Station Road leads past Castle Hill, the site of the Norman motte-and-bailey castle, to the site of the former railway station, now an entry point to the Monsal Trail. Along Baslow Road are Aldern House, headquarters of the Peak District National Park, and Newholme Hospital, pictured, housed in the buildings of the former Bakewell Union Workhouse, which were completed in 1841.

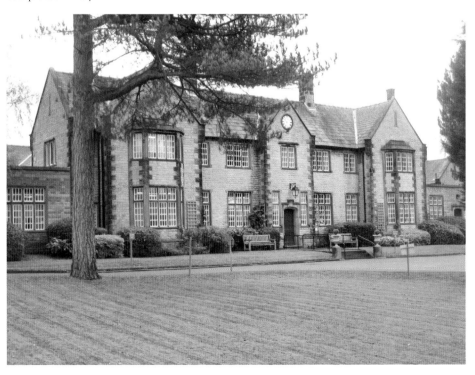

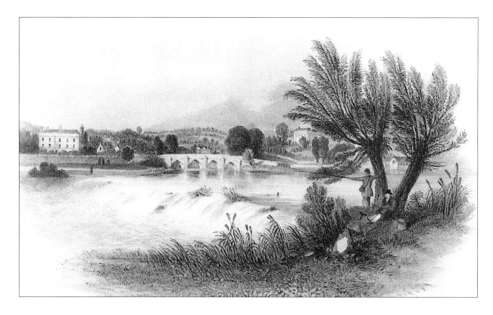

Bakewell Bridge

The upper image, from the 1850s, shows the pleasant setting of Bakewell Bridge. Bakewell Marble Mill can be seen behind the trees on the right and the weir created the millpond for that mill. The lower image shows the scene today from a similar viewpoint, with the riverside promenade on the left, very popular with families for feeding the ducks, and the island that was developed as a landscape feature when the promenade was reconfigured in the late nineteenth century.

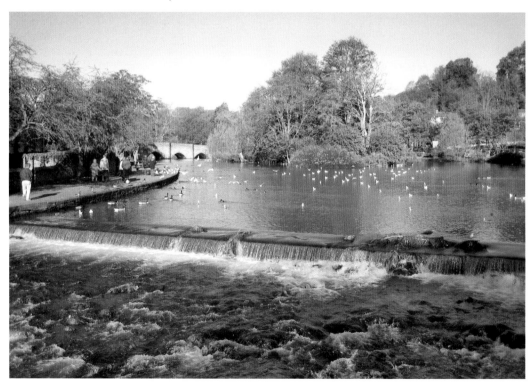

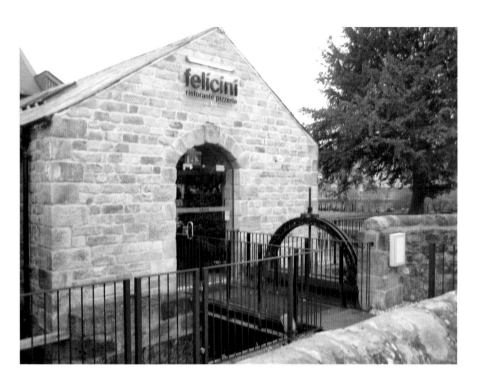

Bakewell Marble Mill

The marble mill was built around 1800 to supply objects made from Ashford Marble (*see page 34*). After a long period of dereliction it was refurbished and opened as a restaurant, seen above, which has an attractive riverside setting. The Rutland Sawmill was opened later on an adjacent site, supplied by the same millpond. After closure as a sawmill, these buildings were redeveloped and they are now in use for a variety of purposes, including as an art gallery and studios, with a display of equipment salvaged from the mills, some of which is seen below.

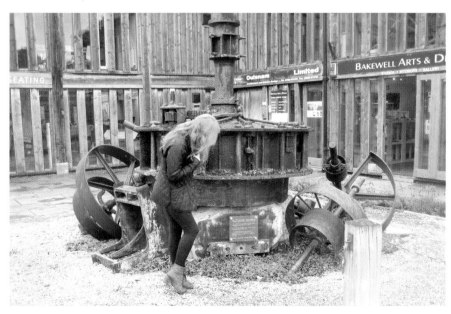

The Agricultural Business Centre

The Agricultural Business Centre was built adjacent to the mill sites on a large site between Coombs Road and the river, with direct access to the A6 across a new bridge and a large number of parking spaces. The upper image shows the main building during the construction phase, while the lower image shows the building's unusual roofline, viewed from higher up on Station Road.

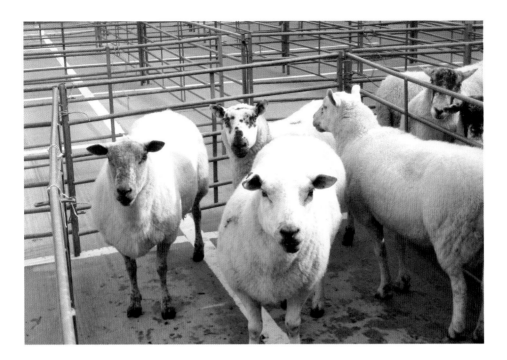

The Livestock Market

The livestock market area has large spaces for the lorries to manœuvre, large holding pens and several auction rings for different types of livestock. In addition, the Agricultural Business Centre has a range of offices, meeting rooms and a café to meet the needs of the agricultural community. A monthly farmers' market is held there. It is said that over 2,500 farms are within the range of the centre, which plays a major part in the well-being of the rural community.

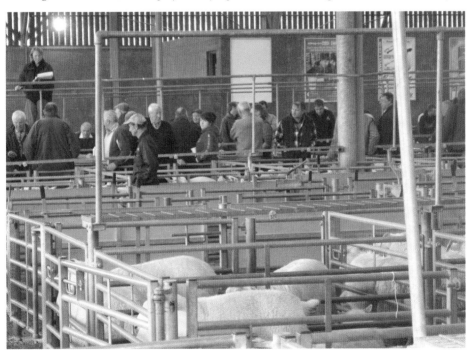

Bakewell Show

Bakewell Show can trace its origins back to 1819, and the show in 2013 will be the 183rd. For many years it was the largest one-day agricultural show in Britain, but is now held over two days in August and attracts many thousands of visitors. The show moved to its present site in Coombs Road in 1929.

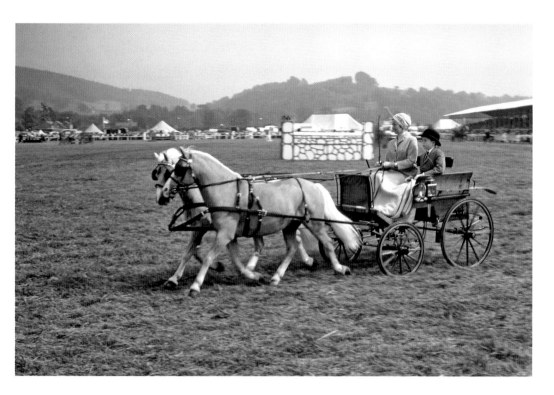

Bakewell Show

There are classes in the show for horses, dogs, cattle, sheep, goats, pigeons, poultry, dairy and meat products, horticulture, floral art and showjumping. In addition, there are many regular attractions for families and special attractions each year.

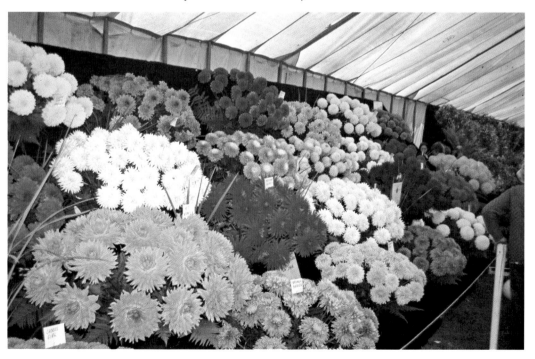

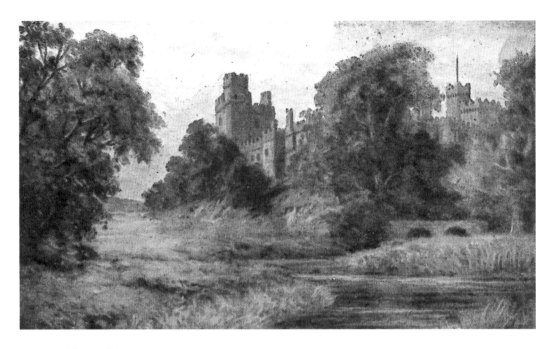

Haddon Hall

Haddon Hall stands on high ground overlooking the Wye, a short distance beyond Bakewell, approached by a typical stone-built bridge across the river. Haddon Hall is a fortified medieval manor house dating from the twelfth century and rebuilt in the early seventeenth century. It lay neglected from 1700 until 1920, when the Duke and Duchess of Rutland restored the house and gardens.

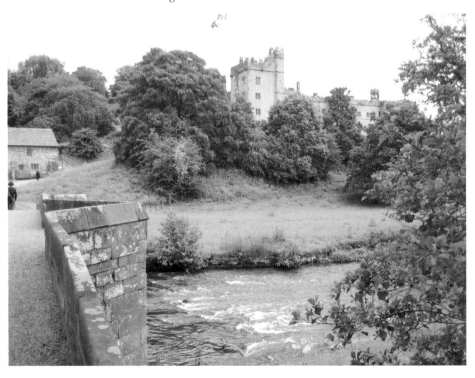

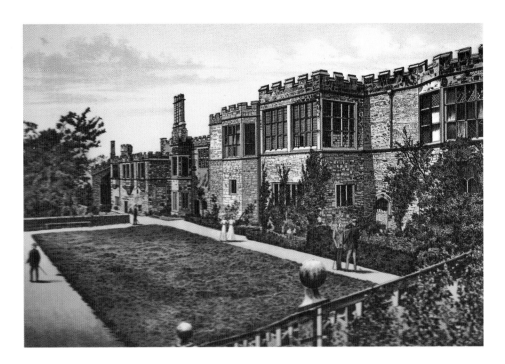

Haddon Hall

Today, Haddon Hall is a fascinating example of Tudor architecture, both internally and externally, with many rooms and furnishings. The Elizabethan terraced garden, with extensive views along the Wye Valley, adds to the interest of a visit. It has been described as 'the most romantic house to survive from the Middle Ages'. Haddon Hall is high on the list of interesting sites to visit in the area.

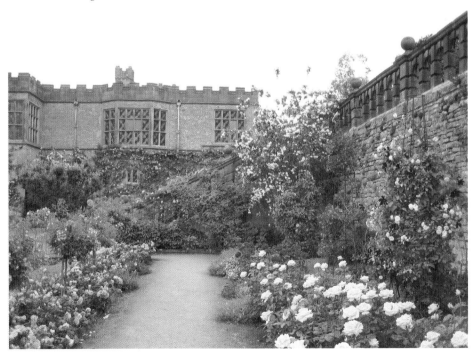

The Approach to Rowsley

Rowsley is the last stop on this journey along the Wye valley – a small village where the Wye flows into the Derwent. The upper image shows the former toll-house on the way into Rowsley from Bakewell. The lower image, for travellers in the opposite direction, shows the large millstone, marking an entry point into the Peak District National Park. The millstone was adopted as the visual symbol for the national park, and similar millstones can be seen at many other entry points to the park.

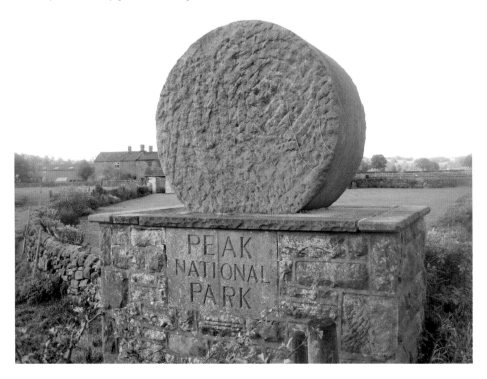

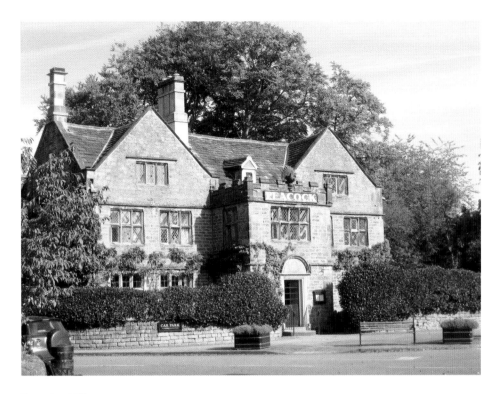

Rowsley Village

The Peacock, above, is a well-established hotel owned by Lord Edward Manners, the owner of Haddon Hall, with fishing rights along 7 miles of the Wye and Derwent. On one side of the Peacock, Church Lane, pictured below, leads up into the village. The bridge, which carried the railway line up towards Bakewell, was demolished following the line's closure in 1968.

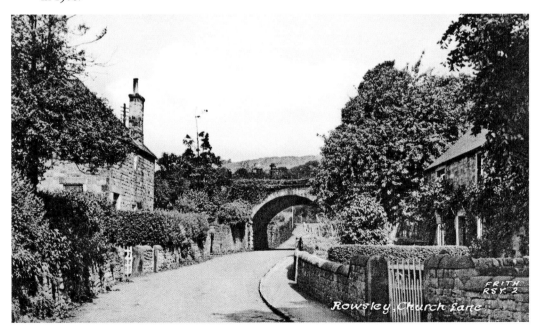

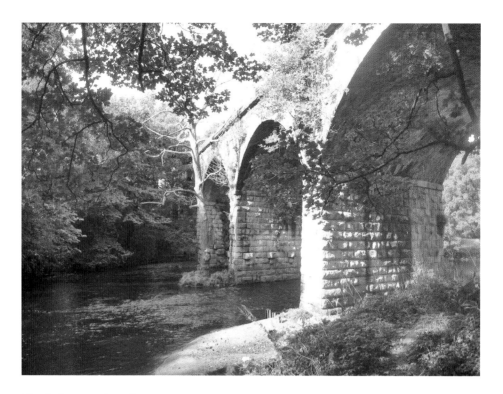

The Railway at Rowsley

The railway coming north from Derby and Matlock reached Rowsley in 1849. The first Rowsley station, designed by Joseph Paxton, was built on the eastern side of the Derwent, with the intention of extending the line along the Derwent Valley past Chatsworth. However, after lengthy discussions the line was extended along the Wye Valley, reaching Buxton in 1863 and Manchester in 1867. This required a bridge across the Derwent, which has survived the line's closure, and a second station on the other side of the road.

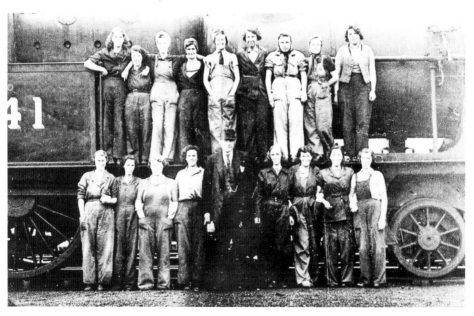

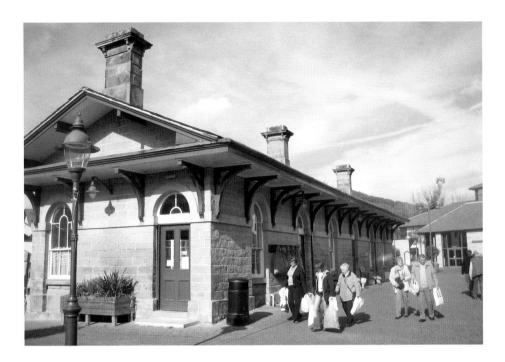

The Former Railway Station

The area around the first station became an important goods yard, and the lower picture on the previous page shows railway staff there in 1942. The Peak Village shopping centre, popular with visitors, was built on the site in 1999. The upper image shows the restored original station building incorporated into this venture, and the lower image shows one of the new buildings there. The Peak Rail heritage line between Rowsley and Matlock operates from a station a short distance away, towards Matlock.

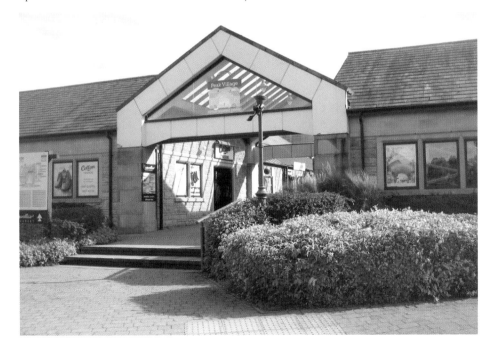

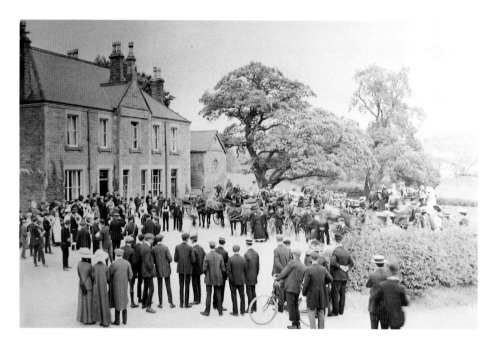

Station Hotel

A bridge accessed by a long embankment was required to take the railway across the road between Rowsley and Matlock (now the A6). The Station Hotel, above, was built adjacent to this bridge. Pictured below, it is now known as the Grouse & Claret Hotel. It was extensively refurbished in Spring 2012 in a 'traditional style with a modern twist'. The rail bridge over the A6 was demolished following line closure, leaving the bridge over the Derwent isolated (*see page 90*).

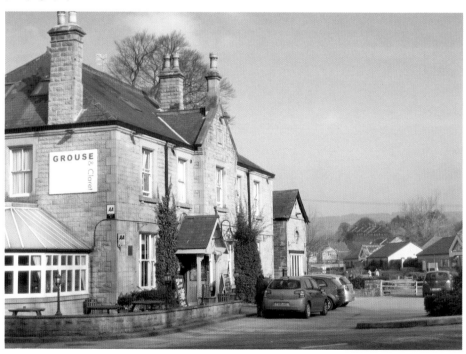

Caudwell's Mill

Caudwell's Mill is across the road from the Peacock Hotel. There has been a corn mill on this site since medieval times. The upper image shows a painting of the mill made in 1853. The mill was completely rebuilt by John Caudwell in 1874, and the lower image shows the main mill building as it is today. Along with many other watermills, electricity generators, powered from the millstream, were added in the late nineteenth century to drive the mill machinery.

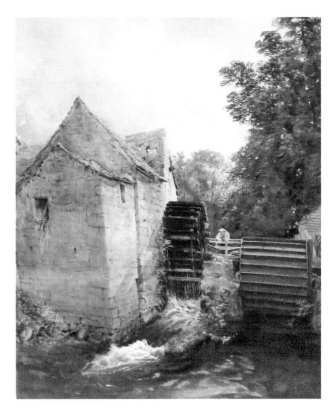

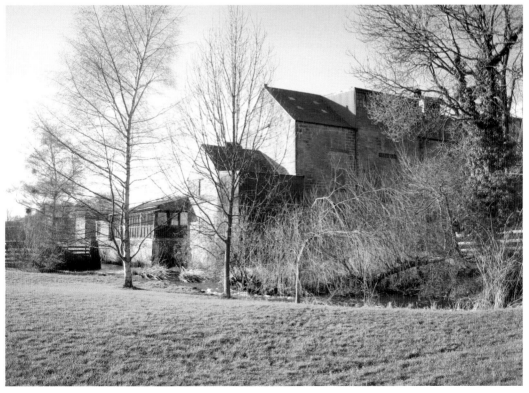

Caudwell's Mill

The mill ceased commercial operation in 1978, and in 1980 the buildings were taken over by a trust, which still operates the mill today. The mill is open to visitors, and on the site are a cafe, craft shop and art gallery, along with ample car parking. The lower image shows the millstream on the approach to the mill, with Stanton Moor in the background, demonstrating how the Wye Valley has opened out into a wide, hill-fringed area, in contrast to its confined journey through the limestone dales.

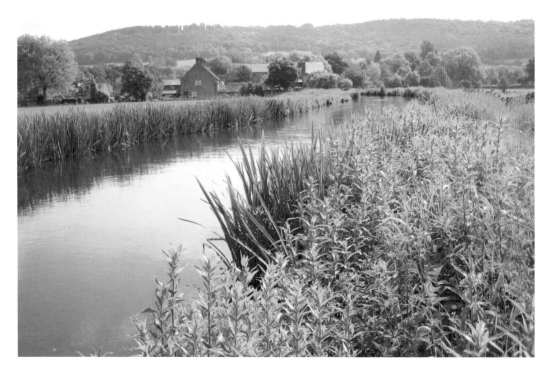

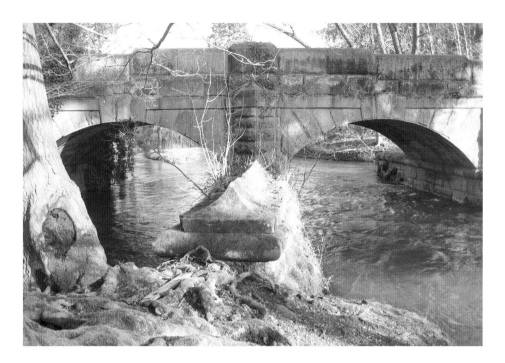

The End of the Journey

The upper image shows the last bridge over the River Wye, where the millstream from Caudwell's Mill (left-hand arch) rejoins the Wye (right-hand arch). The road over the bridge leads on to Stanton Moor. The lower image shows the tranquil spot, 500 yards further on, where the Wye finishes its journey as it flows into the Derwent (on the right), observed mainly by fishermen and grazing cows.

Acknowledgements

In these acknowledgements, images are identified by a two-digit page number followed by 1 for the upper picture on the page or 2 for the lower picture on the page.

Images 17.1, 20.1, 21.1, 23.1 (also on the back cover), 32.1, 42.1, 69.1, 70.1, 73.2, 84.1 and 90.2 are courtesy of Derbyshire Local Studies Library and Picture the Past (www.picturethepast.org.uk.)

Images 47.1, 47.2, 48.1, 50.1 and 51.1 are courtesy of Derby City Council and Picture the Past.

Image 68.2 is courtesy of *Derby Evening Telegraph* and Picture the Past.

Images 36.2 and 65.1 are courtesy of the Brighouse Collection and Picture the Past.

Image 43.2 is courtesy of D. D. Brumhead and Picture the Past.

Image 68.1 (also on the fornt cover) is courtesy of Mr G. Coupe and Picture the Past.

Image 73.1 is courtesy of Anthony Fisher and Picture the Past.

Image 63.1 is courtesy of T. O. Green and Picture the Past.

Images 55.1 and 82.1 are courtesy of Geraldine Holland and Picture the Past.

Image 89.2 is courtesy of Judy Jones and Picture the Past.

Images 84.2, 85.1 and 85.2 are courtesy of T. W. Tyreman and Picture the Past.

Images 33.1, 33.2, 34.2, 35.1, 37.2, 38.1, 39.1, 40.1, 41.1, 43.1, 49.1, 52.2, 53.1, 54.1, 56.1, 56.2, 57.1, 58.1, 59.1, 61.1, 61.2, 62.1, 64.1, 66.1, 66.2, 67.1, 69.2, 76.1, 78.1 and 79.1 are courtesy of Bakewell & District Historical Society (www.oldhousemuseum.org.uk).

Image 26.2 is copyright Ann Hall.

Image 44.1 is courtesy of Mr and Mrs M. Frampton.

Images 62.2 and 63.2 (also on the front cover) are copyright Frank Parker.

Image 93.1 is courtesy of Peter Skinner.